Modern Sculpture at The Nelson-Atkins Museum of Art

An Anniversary Celebration

Modern Sculpture at The Nelson-Atkins Museum of Art
An Anniversary Celebration

with essays by
Deborah Emont Scott and
Martin Friedman

and contributions by
Jan Schall
James Martin and
Leesa Fanning

Published by the Nelson Gallery Foundation, Kansas City, Missouri

Library of Congress Cataloging-in-Publication Data

Scott, Deborah Emont, date.
 Modern sculpture at the Nelson-Atkins Museum of Art : an
anniversary celebration / Deborah Emont Scott, Martin Friedman.
 p. cm.
 ISBN 0-942614-31-3
 1. Sculpture, Modern — 20th century Catalogs. 2. Sculpture—
Missouri—Kansas City Catalogs. 3. Nelson-Atkins Museum of Art
Catalogs. I. Friedman, Martin L. II. Nelson-Atkins Museum of Art.
III. Title.
NB25.K6N457 1999
735'.23'074778411—dc21 99-27051
 CIP

Printed by Richardson Printing, Inc. in the United States of America

Table of Contents

Preface ...vii
 Marc F. Wilson

Introduction ...x
 Donald J. Hall

The Kansas City Sculpture Park:
Vision and Commitment1
 Deborah Emont Scott

Modern Sculpture at
The Nelson-Atkins Museum of Art................................9
 Martin Friedman

Artists and Works ..33

Acknowledgments.....................................81

(Fig. 1) The west end of The Kansas City Sculpture Park at The Nelson-Atkins Museum of Art

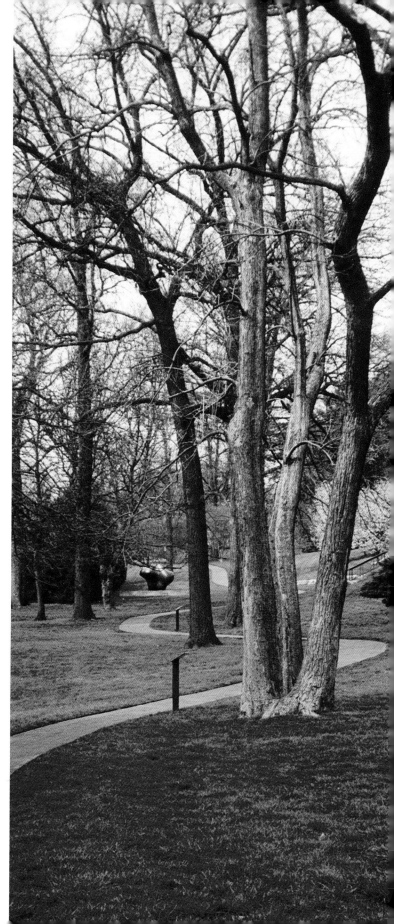

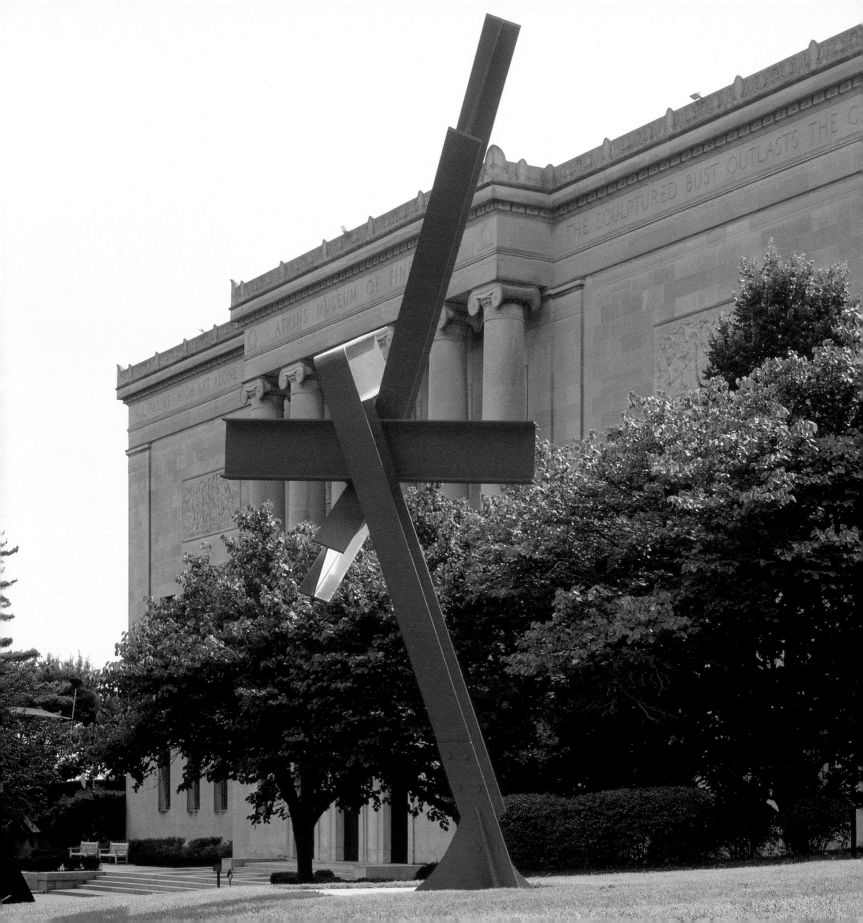

Preface

Perhaps no initiative of The Nelson-Atkins Museum of Art so embodies the spirit of this institution on the eve of a new century as does the Kansas City Sculpture Park. It is various, vigorous, celebratory, challenging and changing. It commands and conveys respect for the works and their artists, in ways that are wonderfully accessible and inviting. It belongs to an important tradition of museum collection and study, but also to the equally important promise of public appreciation. Nowhere else is there anything just like it.

The vision of sculpture in a park has been intriguing since the first sculpted image was set outside. The moment or idea captured and held still in a sculpted material, such as bronze, marble, or metal, seems paradoxical outdoors, where nature is never still, but is every minute moving, changing, living, dying. This paradox is essential to the compelling quality of the Sculpture Park at the Nelson-Atkins.

From the opening of the Park in June of 1989, anyone who has walked amidst the flicker of sunlight and leaf shadows on the 13 monumental Henry Moore sculptures feels this dynamic. The ancient gravity of the bronze, the modernity of Moore's vision, the fresh life of the leaves — together these sum up the magic of the Sculpture Park.

In very real ways, the Park is like music. In it, light, shadow, time, topography, vegetation are continuously recombining in different ways like an active composition. Moving through the garden, a visitor experiences interludes — some portions seem an allegro tempo, others andante — in a special rhythm that is very much the Park's own. And throughout, the sculptures stand in vital counterpoint to this movement of nature.

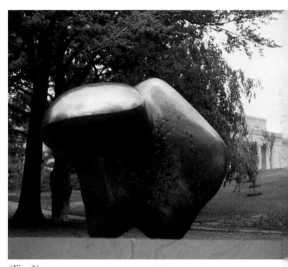

(Fig. 3)
Henry Moore
British, 1898–1986
Three Way Piece No. 1: Points, 1965–1966
bronze
78 x 82 x 93 in. (198.1 x 208.3 x 236.2 cm)
The Hall Family Foundation Collection at
The Nelson-Atkins Museum of Art
2-1987/1

(Fig. 2) (facing page)
Mark di Suvero
American, b. 1933
Rumi, 1991
painted steel
24 ft. high (731.5 cm)
The Hall Family Foundation Collection at
The Nelson-Atkins Museum of Art
1-1996

The special dynamic of contrasts is important to many aspects of the Park. It celebrates a collection that is timeless in its artistic endeavors and interests, yet current in its modern expression. It is a welcoming public place made largely possible by the generosity of private gifts. On a pretty afternoon, scholars and preschoolers may be seen experiencing the same piece, all in their own ways. Nothing about the Park is mundane, yet it is *ordinary* in the truest sense of the word — it is available every day to every one.

The Park itself is a work in progress, literally growing before our eyes, with seasons of rest followed by renewed creation. It is a stately place, echoing the formality of the Museum structure, but attracting the liveliest forms of community leisure, from musical performances to impromptu Frisbee matches. It is uniquely Kansas City's park, yet it more and more belongs to the world, as the collection grows and the word spreads.

To separate the growth of the collection (and its potential growth) from the opportunity the Park presents is not really possible. Historically, the Museum has been strong in areas represented by the founders' original vision, which was a comprehensive collection that would display selected and distinguished examples of the fine arts of all civilizations from all periods. Since 1983, when chief curator and Sanders Sosland curator of modern and contemporary art Deborah Emont Scott came to the Museum, the portfolio of modern and contemporary European and American art has rounded out considerably.

To carry this development forward most effectively, efforts began to focus on collecting modern sculpture. Like others of the most important developments at the Museum, these efforts are a result of the Museum's reliance on donors and patrons of outstanding generosity.

From the start, a critical role has been played by Donald J. Hall, Chairman of the Hall Family Foundation and its board. The Foundation is a private philanthropic organization dedicated to enhancing the quality of human life in the Kansas City area. In 1986, the Foundation's purchase of more than 50 works by Henry Moore led to its three-way partnership with the Museum and the Kansas City Board of Parks and Recreation Commissioners (who owned the parkland surrounding the Museum) to construct a sculpture park — what was then called the Henry Moore Sculpture Garden — which opened in 1989. The Park Board offered much more than their expertise; they also contributed financially to the original park partnership. In 1998, ownership of the parkland transferred to the Trustees of the Nelson-Atkins Museum, but the imprint of the Park Board's early influence remains an important part of the history of the Kansas City Sculpture Park.

In addition to establishing the Kansas City Sculpture Park, the Henry Moore acquisitions laid the foundation for establishing the Modern Sculpture Initiative in 1991. As part of this initiative, more than 40 donors have generously contributed both indoor and outdoor sculptures to the Museum's collection during the past decade. In 1994, for example, *Shuttlecocks*, the first outdoor sculpture commissioned for the Museum, was installed in the Park. This four-part sculpture by Claes Oldenburg and Coosje van Bruggen was an extraordinary gift from the Sosland family. Many other important donations are highlighted later in this volume, while Deborah Emont Scott's essay provides rich and fascinating histories of the Kansas City Sculpture Park and the Modern Sculpture Initiative.

Martin Friedman has also played a valuable role in our efforts. Friedman is director emeritus of the Walker Art Center in Minneapolis, Minnesota, which he directed for some 30 years until his retirement in 1990. At the Walker, Friedman established the Minneapolis Sculpture Garden. Since 1990, Friedman has been an arts adviser to the Hall Family Foundation, among many other active projects. As adviser to the Hall Family Foundation, he has worked magic, at times resembling Merlin. Working closely with Deborah Emont Scott, he has contributed years of experience to our program.

How wonderful it is on the occasion of the Park's 10th anniversary to reflect on the success it already has achieved and the promise that lies ahead. The sculpture collection and the environments that house and display it bring together the past, present and future in ways that invite private reflection and public pleasure. They stimulate inquiry, learning and inspiration.

The entire effort is a testament to an enormous civic, artistic and scholarly collaboration. Indeed, the Park was envisioned and created by donors, community leaders, corporations, trustees, directors, curators, designers, artists and appreciative citizens. And the whole continues to grow — the Park, the modern sculpture collection and the numbers of persons who work to develop it and those who come to enjoy it. Looking both behind and before us, as anniversaries always invite us to do, we are reminded of Rudyard Kipling's line, "And the Glory of the Garden shall never pass away."

Marc F. Wilson
Director and Chief Executive Officer

The Nelson-Atkins Museum of Art
Kansas City, Missouri

Introduction

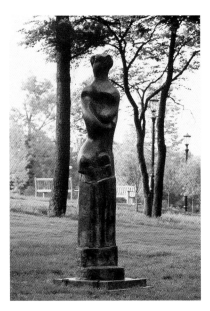

(Fig. 4)
Henry Moore
British, 1898–1986
Upright Motive No. 9, 1979
bronze, ed. of 6
144 x 41 1/2 x 41 1/2 in.
(365.8 x 105.4 x 105.4 cm)
The Hall Family Foundation Collection at
The Nelson-Atkins Museum of Art
66-1986/6

Years ago, when considering how best to support the Nelson-Atkins Museum, we sought the counsel of Seymour Slive, then director of the Fogg Museum at Harvard University. He had two principal recommendations that have since guided our thinking and that of the Hall Family Foundation.

The first was to build on the Museum's exceptional Oriental collection. The second was to capitalize on the Nelson-Atkins' extensive and beautiful grounds — a unique asset among urban museums. Specifically, Dr. Slive saw the great expanse of the south lawn as an ideal setting for monumental sculpture.

Creating a sculpture park had considerable appeal. Such a park would provide an opportunity for the Museum to focus on 20th-century art, complementing the richness of its other collections. In addition, prices for monumental sculpture were more reasonable, because few museums had the space to display such pieces. We therefore might be able to build a collection of some significance.

With the purchase in 1986 of nine monumental pieces by Henry Moore, our dream began to take shape. We could hardly have imagined a better beginning. Over the years, the collection has continued to grow in scope and stature, with the addition of major works by Brancusi, Noguchi, Giacometti, Ernst and others.

Today, when I walk through the park, I am struck not only by the energy and beauty of the works themselves, but also by the way this space draws people. To me, one of

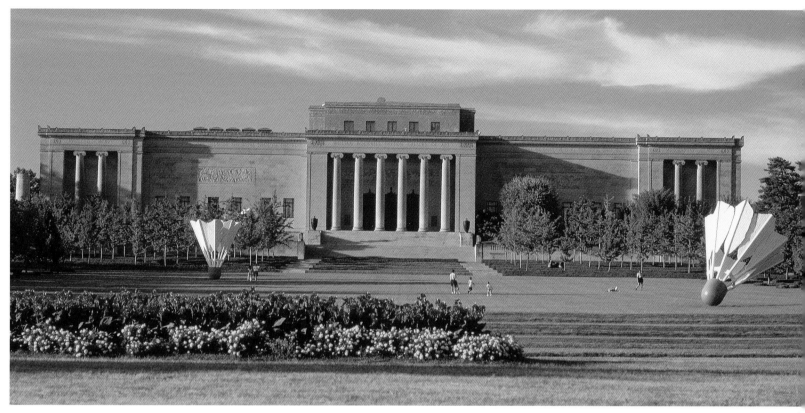

(Fig. 5) South facade of The Nelson-Atkins Museum of Art

the greatest satisfactions of the sculpture park is the way it has extended the Museum's reach into the community. Its spacious lawns, quiet pace and accessible art — especially Oldenburg and van Bruggen's *Shuttlecocks* — provide an invitation to anyone who might find the Museum itself intimidating.

My hope is that the Kansas City Sculpture Park will continue to be a place of joy and inspiration, where future generations can discover the power of art to express the deepest yearnings of the human spirit.

Donald J. Hall
Chairman, Hallmark Cards, Inc.

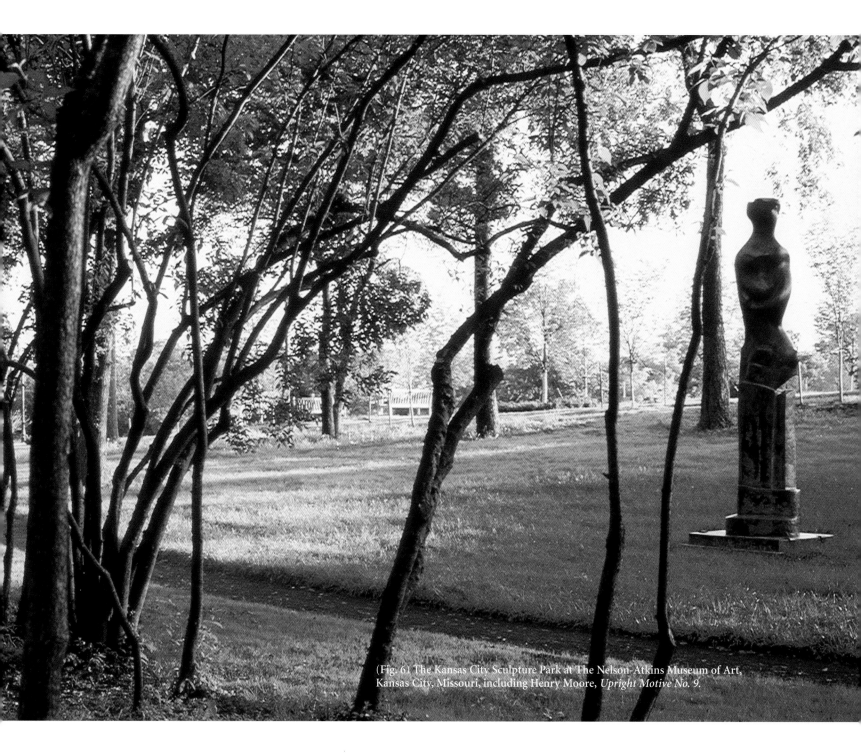

(Fig. 6) The Kansas City Sculpture Park at The Nelson-Atkins Museum of Art, Kansas City, Missouri, including Henry Moore, *Upright Motive No. 9.*

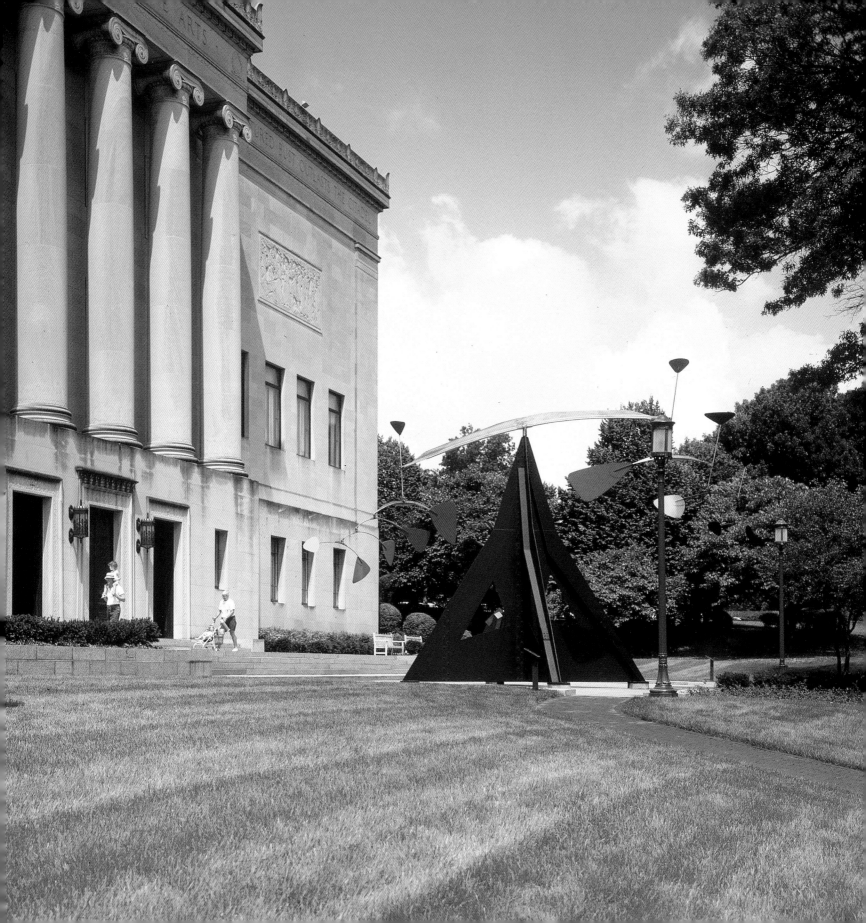

The Kansas City Sculpture Park: Vision and Commitment

As it celebrates its 10th anniversary, the Kansas City Sculpture Park has achieved recognition as a pre-eminent collection of important modern sculpture and a simply wonderful place to be. Visitors from all over the world are delighted by the power of the collection and by the beauty of the Park. Area residents have made it one of Kansas City's best-loved destinations.

The Kansas City Sculpture Park is a happy blend of a commitment to develop a particular area of collecting in the Nelson-Atkins Museum and a dynamic realization of the potential of a special urban outdoor space. The Park led to the Modern Sculpture Initiative, a comprehensive plan to strengthen the Museum's engagement with modern sculpture. Since its inception, the Sculpture Initiative has focused on acquiring works that are representative of key 20th-century movements and artists. This strategy has ensured a wide-reaching collection that offers visitors a nearly unparalleled experience of modern sculpture. The vision for this collection demanded a coordinated use of indoor and outdoor space, so that each work could be shown in its most suitable environment. The result is an exceptional experience for the visitor, and for each sculpture a home that permits appropriate care and display.

The groundwork for the collection was laid in 1986 when the Hall Family Foundation acquired a group of more than 50 Henry Moore bronze sculptures. The Hall Family Foundation then collaborated with the Nelson-Atkins and the Kansas City Board of Parks and Recreation Commissioners, the owners of the 44 acres of public land surrounding the Museum, to plan the Henry Moore Sculpture Garden.

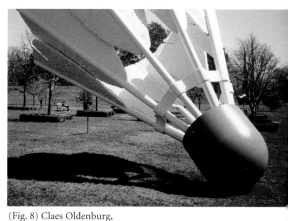

(Fig. 8) Claes Oldenburg,
American, born Sweden, 1929
Coosje van Bruggen,
American, born The Netherlands, 1942
Shuttlecocks, 1994
aluminum and fiberglass
4 elements:
19 ft. 2 1/2 in. x 17 ft. 5 in. x 15 ft. 11 3/4 in. (5.9 x 5.3 x 4.9 m)
20 ft. x 15 ft. x 15 ft. 11 3/4 in. (6.1 x 4.6 x 4.9 m)
17 ft. 11 3/4 in. x 17 ft. 5 in. x 15 ft. 11 3/4 in. (5.5 x 5.3 x 4.9 m)
18 ft. 3 1/2 in. x 18 ft. 10 in. x 15 ft. 11 3/4 in. (5.6 x 5.7 x 4.9 m)
Purchase: acquired through the generosity of the Sosland Family
F94-1/1-4

(Fig. 7) (facing page)
Alexander Calder
American, 1898–1976
Ordinary, 1969
steel plate
top: 38 ft. 1 in. (11.6 m)
base: 20 ft. 1 in. x 19 ft. 8 in. x 19 ft. 8 in. (6.1 x 6 x 6 m)
The Nelson-Atkins Museum of Art,
on loan from a private collection
20-1994

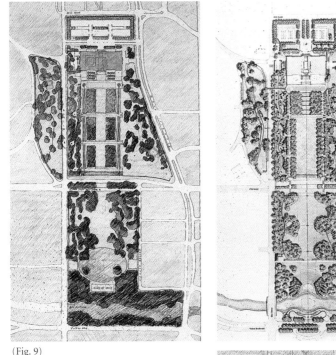

(Fig. 9)
Alternative concepts, 1988.

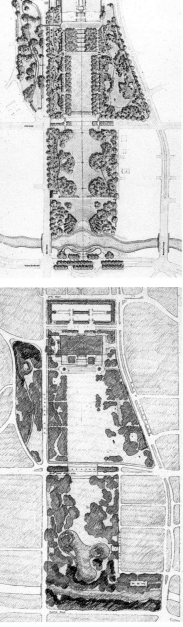

Internationally recognized architects Dan Kiley and Jaquelin Robertson were invited to design the 17-acre Sculpture Garden, which opened in 1989 (Fig. 11).

The Selection Committee chose the most formal (Fig. 10) of Kiley and Robertson's three proposed designs (Fig. 9) in order to maintain consistency with the traditional milieu of the Museum's Neoclassical building. The rich variety of plant life in this selected design includes more than 50,000 daffodils; more than 10,000 Japanese Yew; 100 American Linden, Ginkgo, Crab Apple, Norway Spruce and River Birch trees; and more than 4,000 square feet of Baltic Ivy.

The sculpture collection quickly grew. In 1991 the Nelson-Atkins and the Hall Family Foundation acquired from a private Dallas collection five masterpieces, including major works by Brancusi, Ernst, and Giacometti. Soon after these important acquisitions, the Museum received as gifts works by Elie Nadelman, Ossip Zadkine, and Donald Judd from collectors who recognized the Museum's deepening commitment to modern sculpture.

As the Museum's collection expanded, it was clear the sheer variety of outstanding 20th-century works and their considerable cost would make it impossible to represent all movements and artists. The sharpened focus became the Modern

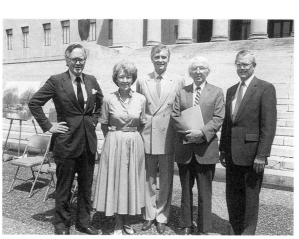

(Fig. 11) Opening of the Henry Moore Sculpture Garden, June 2, 1989. Jaquelin Robertson, architect; Anita B. Gorman, President, Kansas City Board of Parks and Recreation Commissioners; Marc F. Wilson, Director; Dan Kiley, architect; and Donald J. Hall, trustee.

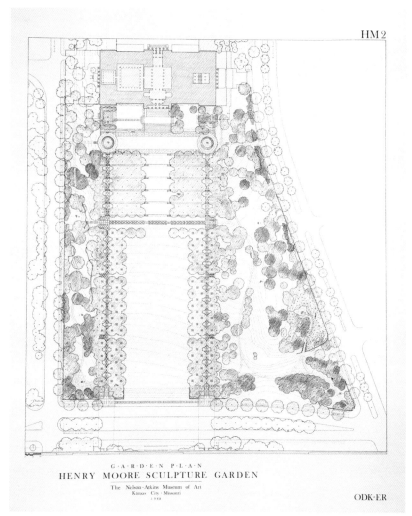

(Fig. 10) Henry Moore Sculpture Garden, final plan, 1988.

(Fig. 12)
Isamu Noguchi
American, 1904–1988
Night Land, 1947
York fossil marble
22 x 47 x 37 1/2 in. (55.9 x 119.4 95.3 cm)
The Hall Family Foundation Collection at The Nelson-Atkins Museum
of Art
30-1992/1

Sculpture Initiative, implemented in 1992, which has guided acquisitions and emphasized collecting key artistic achievements of outstanding creative figures in modern and contemporary sculpture. The Sculpture Initiative has changed the nature of the Museum's modern collections and contributed to the "historical narrative" of its holdings. It has also created rich opportunities to stress the important connections between modern sculpture and the art of the past.

Guided by the Sculpture Initiative's parameters, the Museum's sculpture collection has steadily grown. In 1993 the Hall Family Foundation acquired for the Museum two important stone sculptures by Isamu Noguchi, *Night Land* (Fig. 12, Plate 40) and *Six-foot Energy Void* (Plate 42); a standing mobile by Alexander Calder; an untitled work by Joel Shapiro; and *Soft Saxophone, Scale B* (Plate 43) by Claes Oldenburg. Later in 1994, at the invitation of the Sosland Family of Kansas City, Claes Oldenburg and Coosje van Bruggen created and installed *Shuttlecocks* (Figs. 8, 15, 16, Plate 44), a four-part sculpture sited on the sweeping greensward of the Nelson-Atkins Museum.

Acquisitions such as an impressive bronze figurative group by George Segal and a 24-foot-tall painted steel sculpture by Mark di Suvero made evident the need to expand the garden. With the support of the Hall Family Foundation and the Kansas City Board of Parks and Recreation

Commissioners, the East Garden was designed and dedicated in May 1996. The East Garden is now part of the renamed Kansas City Sculpture Park, which includes the Henry Moore Sculpture Garden, *Shuttlecocks* and the Elmer F. Pierson Sculpture Garden.

The collection has continued to grow: the Hall Family Foundation acquired a 16-foot tower structure by Sol LeWitt, and the Nelson-Atkins purchased a nearly 10-foot-long cornucopia-shaped wooden sculpture by Martin Puryear. Generous donors also have made gifts, including an earlier work by Sol LeWitt, a fluorescent light sculpture by Dan Flavin, an important Assemblage piece by Alison Saar, a large wooden work by the Czechoslovakian artist Magdalena Jetelova, and three important works by Louise Nevelson. In 1998, an impressive collection of five works by Isamu Noguchi was acquired. These works will one day be grouped with two previous Noguchi acquisitions in a "Noguchi Court" being envisioned for an expanded museum. In 1998 and 1999, outstanding works were acquired for display in the Sculpture Park, including Magdalena Abakanowicz's *Standing Figures (Thirty Figures)* (Plate 1) and Ursula von Rydingsvard's *Three Bowls* (Plate 55). In addition, two new works were commissioned — an 80-foot-long sculpture by Robert Stackhouse, and Judith Shea's *Storage* (Plate 53). Finally, the Museum's collection of works by Siah Armajani now numbers 11, thanks to recent gifts.

As the Museum looks toward the future, plans are to continue collecting major sculptures for exhibit in both the Museum galleries and the Sculpture Park, with hope for increasing the representation of work by younger artists. In addition, a thematic area is emerging based on the notable strengths of the current collection as acquisitions such as the Segal, Shea and Abakanowicz hearken back to Moore's figurative tradition.

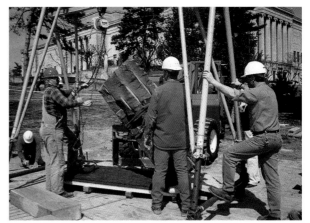

(Fig. 13) Installation of Isamu Noguchi's *Ends*, 1996.

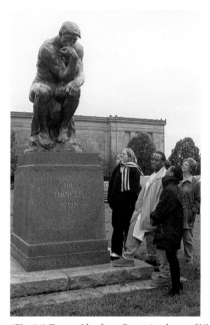

(Fig. 14) Teen guides from Paseo Academy of Visual and Performing Arts view *The Thinker*:
(left to right) Senta Blackman, Chesere Jones, Chrishawna Truss and sculpture teacher Rusty Newton.
Auguste Rodin
French, 1840–1917
The Thinker, 1880
bronze
73 x 58 x 39 in. (185.4 x 147.3 x 99.1 cm)
Board of Parks and Recreation Commissioners,
Gift of Grant I. and Mathilde Rosenzweig, 1948

5

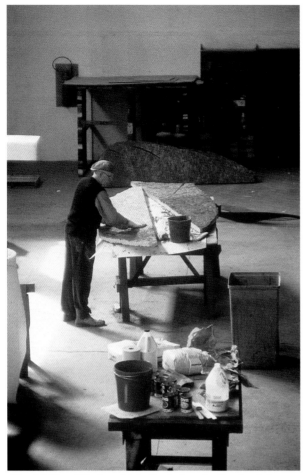

(Fig. 15) Claes Oldenburg fabricating feathers for *Shuttlecocks* in March 1994

The Modern Sculpture Initiative is ambitious, with a comprehensive, long-range strategy that calls for acquisitions of important sculpture, but also for broad support for the study and enjoyment of sculpture. The plan includes the collection of significant supporting materials for key sculptures in the collection, such as drawings, maquettes, documentary photographs and artists' notebooks. Additionally, it supports a sculpture study center to encourage research on the collection, with slides, periodicals and books, exhibition catalogs, films and videos about modern sculpture. Also addressed in the plan is a wide range of educational programs to introduce the sculpture collection to the viewing audience.

Since 1992, programs for all ages have been presented in the galleries and in the Park. To mark the 10th anniversary of the Kansas City Sculpture Park, the Nelson-Atkins produced an audio tour of the Park in conjunction with the Acoustiguide Corporation. This vital educational tool allows visitors to listen to a wide range of interpretive comments about 15 selected sculptures as they walk through the Park. The tour features 35 minutes of programming for adults and 15 minutes for children.

My thanks to the Hall Family Foundation, especially Donald J. Hall, Chairman; William A. Hall, President; and past and current Vice Presidents Peggy Collins and Jeanne M. Bates, for enlightened support of the program; to the numerous donors whose names appear on page 81; to Martin Friedman, whose advice and friendship make this project a curator's dream; and to Nelson-Atkins staff members who have, during the decade, enriched the program with their expertise and dedication. Their names appear on page 83. Finally, for their support of this publication, I wish to thank James Martin for his supervision, and Jan Schall and Leesa Fanning for their entries.

With a decade of marvelous growth to build upon, the Nelson-Atkins Museum is very enthusiastic about the prospects for the structured-but-steady development of its comprehensive modern sculpture collection — and audiences to enjoy it.

Deborah Emont Scott
Chief Curator and
Sanders Sosland Curator
of Modern and Contemporary Art

The Nelson-Atkins Museum of Art
Kansas City, Missouri

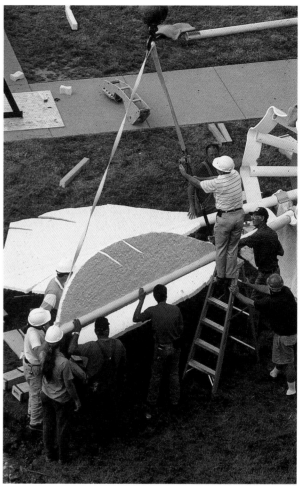

(Fig. 16) Installation of *Shuttlecocks*, 1994

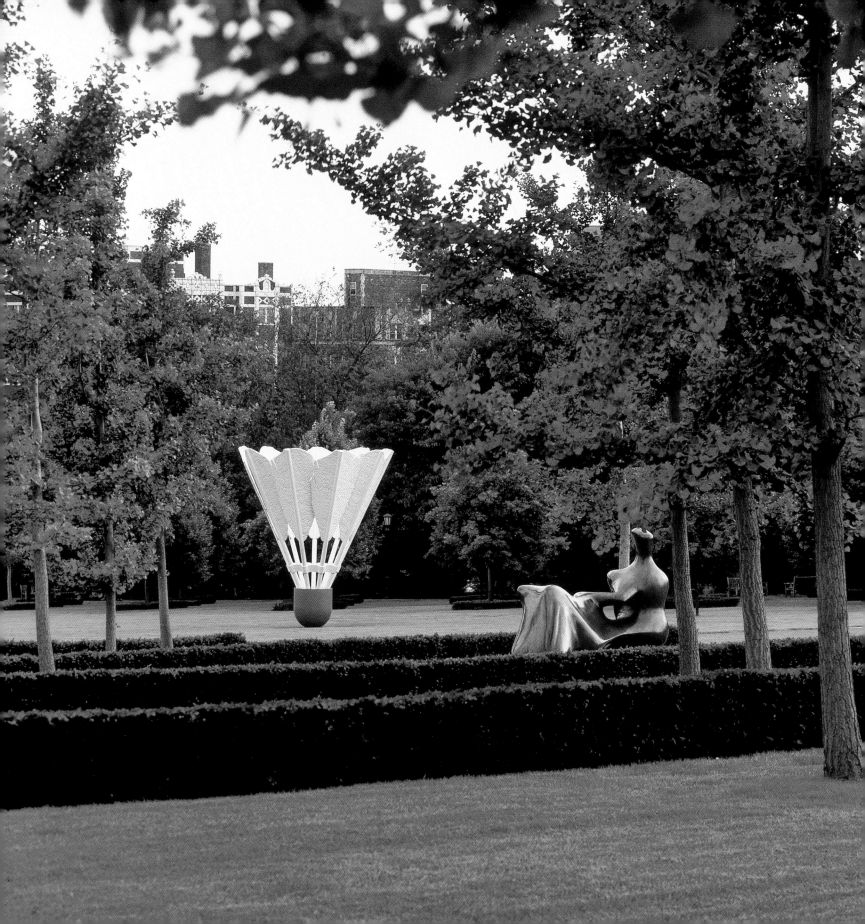

Modern Sculpture at The Nelson-Atkins Museum of Art

Every art museum has a distinct personality, based as much on its collections as on its building, exhibitions, and other programs. While "identity" is instantly apparent in specialized museums wholly devoted, say, to medieval tapestries, 18th-century European art, or contemporary painting and sculpture, it also is evident in those general museums where an area of their collection stands out for its breadth and excellence. A convincing example of such specialized strength is found at The Nelson-Atkins Museum of Art in Kansas City. The Museum has long been celebrated for its stellar holdings in Asian art and, more recently, historical European painting. Now, to these specialized collecting areas must be added a new one: modern sculpture. Rare as it may be these days for a general museum suddenly to pursue a major new sphere of collecting, this is precisely what has occurred at the Nelson-Atkins over the last 10 years. From an institution with a low profile in documenting the march of Modernism, the Nelson-Atkins now is increasingly known for this artistic emphasis.

(Fig. 18) The Nelson-Atkins Museum of Art, with Henry Moore's *Sheep Piece*

The acquisition of a group of Henry Moore bronzes in 1986 by Kansas City's Hall Family Foundation and the subsequent installation of these in the Museum and the Kansas City Sculpture Park set the precedent for this heightened focus on modern sculpture. Such focus, it was felt, could help the Museum illuminate the evolution of Modernism from the late-19th century to the present. This new approach was formalized in 1992 as the Nelson-Atkins' Modern Sculpture Initiative, a policy that helped bring a substantial number of major works of art, many of them discussed in this characterization, into the collection.

(Fig. 17) (facing page) The Kansas City Sculpture Park with Claes Oldenburg and Coosje van Bruggen's *Shuttlecocks* and *Reclining Figure: Hand* by Henry Moore

9

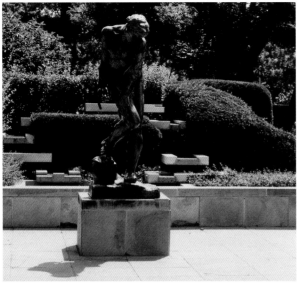

(Fig. 19)
Auguste Rodin
French, 1840–1917
Adam, 1880
bronze
77 x 29 x 29 in. (195.6 x 73.6 x 73.6 cm)
Purchase: Nelson Trust
55-70

(Fig. 20)
Alexander
Archipenko
American, born
Russia, 1887–1964
*Statue on Triangular
Base*, 1914
bronze
height 29 7/8 in.
(75.9 cm)
Gift of Mrs. Louis
Sosland
F77-24

Early Modernism at the Nelson-Atkins

Even before the Initiative began changing things so dramatically, the Nelson-Atkins had some history of collecting modern sculpture. Decades earlier, the Museum acquired several late-19th-century sculptures by artists whose work, from today's perspective, was crucial to Modernism's genesis. Of these, the most significant are two bronze male nudes by Auguste Rodin: vintage casts of *Adam* (Fig. 19, Plate 48) and the iconic *The Thinker* (Plate 49), both circa 1880 and both indicative of that protean master's ability to stand French academic realism on its head. These quasi-mythical beings, with their theatrical poses and Michelangeloesque musculature, were mute transmitters of Rodin's vast emotional energy. *Adam*, head bowed and knee bent, stands in a state of reverie in the walled space of the Pierson Sculpture Garden adjoining the Nelson-Atkins, and *The Thinker*, on permanent loan from the city of Kansas City, is a seated sentinel at the building's north entrance. As with all Rodin's figures, the light-reflecting, uneven surfaces of these bronzes are a record of the rapid, spontaneous clay modeling process he favored, whereby the model became a point of departure for improvisations far beyond the factual depiction of anatomy.

Also acquired well before the Modern Sculpture Initiative — and stylistically in marked contrast to the theatricality of the Rodin sculptures — were several other outstanding bronzes that reflect various influential early-20th-century European stylistic modes. Two works that employ Cubism's codified abstract language are the sleek *Statue on Triangular Base* (Fig. 20, Plate 2), a 1914 female nude by Alexander Archipenko, and Jacques Lipchitz's 1917 *Bather* (Plate 23), a dynamic cluster of rectangular solids. On the Expressionist side is German sculptor Ernst Barlach's 1910 *The Madman (Der Berserker)* (Fig. 21), where the figure's violent movement takes prece-

dence over any descriptive details. In an emotion-saturated manner, Barlach sought to portray the subject's tumultuous inner state. Sculptures by two Europeans who came to the United States early in their careers offer yet other responses to the human form. One is the Polish-born Elie Nadelman's *Standing Girl*, 1918–1920 (Plate 33), an image of a serenely posed young woman carved in cherry wood, some of whose surface the artist highlighted in paint. For his figurative works Nadelman frequently drew upon influences as diverse as classical Greek sculpture and, in this instance, American folk-art carvings. The other, *Head of John Marin* (Fig. 22), 1928, by the French-born Gaston Lachaise, is an energetic, rough-surfaced, somewhat Rodinesque study of the legendary American landscape painter. Recently, another and stylistically more characteristic Lachaise sculpture was added to the Museum's collection: *Bas Relief Woman*, ca. 1930–1935 (Fig. 23), is one of his many elegant sculptural homages to Isabel, his beloved wife and constant model. As in all his interpretations of his muse, he exaggerates her sinuous curves and ample proportions in this highly stylized bronze relief.

Surrealist Echoes: Mythology Takes on Three-Dimensional Form

The first stylistically cohesive Modernist works at the Nelson-Atkins are several Surrealist-related sculptures from the mid-1940s — well after the movement's Paris heyday in the 1920s and 1930s. Largely shaped by new ideas about the realm of the unconscious as revealed by Freudian psychology, this movement probed the realm of Greek mythology and the dream worlds of primitive aboriginal societies, where history, legend and the demonic were interchangeable. Surrealism's ideas persisted in the imagery of many émigré artists from France and Germany who sought refuge in New York during

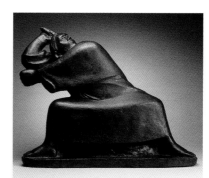
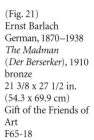

(Fig. 21)
Ernst Barlach
German, 1870–1938
The Madman
(*Der Berserker*), 1910
bronze
21 3/8 x 27 1/2 in.
(54.3 x 69.9 cm)
Gift of the Friends of Art
F65-18

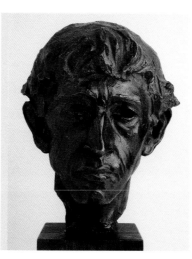

(Fig. 22)
Gaston Lachaise
American, born
France, 1882–1935
John Marin, 1928
bronze
12 1/2 x 9 x 8 1/2 in.
(31.7 x 22.8 x 21.5 cm)
Gift of the Friends of Art
57-99

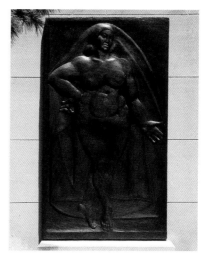

(Fig. 23)
Gaston Lachaise
American, born
France, 1882–1935
Bas Relief Woman,
ca. 1930–1935; 1993
bronze, ed. 2/8
86 x 50 x 3 3/8 in.
(218.4 x 127 x 8.6 cm)
Purchase: The
George H. &
Elizabeth O. Davis
Fund
F99-4

11

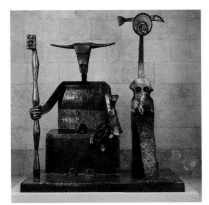

(Fig. 24)
Max Ernst, French, born Germany, 1891–1976
Capricorn, 1948; cast 1963–64
bronze
95 1/2 x 82 x 55 1/4 in.
(242.6 x 208.3 x 140.3 cm)
The Patsy and Raymond Nasher Collection
at The Nelson-Atkins Museum of Art,
lent by the Hall Family Foundation
37-1991/3

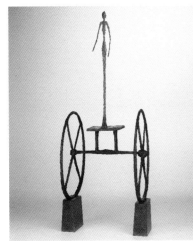

(Fig. 25)
Alberto Giacometti
Swiss, 1901–1966
The Chariot, 1950
painted bronze
56 1/4 x 24 1/4 x 27 in. (142.9 x 61.6 x 68.6 cm)
The Patsy and Raymond Nasher Collection
at The Nelson-Atkins Museum of Art,
lent by the Hall Family Foundation
37-1991/4

World War II. Their forays into this *terra incognita* in turn provided a road map for young American artists also eager to explore reality's hidden side, among them Abstract Expressionism's future progenitors, Barnett Newman, Mark Rothko, Jackson Pollock, and Robert Motherwell.

So powerful was Surrealism's magnetism, many artists outside its immediate circle soon felt its pull. Primarily expressed through paintings, its dream-world premise also affected sculpture, especially since early proponents like Joan Miró, Jean Arp, Alberto Giacometti, and Max Ernst were prolific in both mediums. Surrealism's effect on sculpture engendered a variety of thematic and stylistic approaches, as several works at the Nelson-Atkins readily reveal. These range from Ernst's quasi-human effigies, the subjects of his 1948 magisterial bronze, *Capricorn* (Fig. 24, Plate 13), to Arp's ripe-bodied, indeterminate masses, as exemplified by *Seen and Heard* (Fig. 30), a 1942 gilded bronze. Like his fellow Surrealists, Ernst borrowed heavily from historical sources, combining these gleanings with images derived from his unconscious to arrive at a uniquely personal iconography. Employing a subtle synthesis of fantasy and wry humor, he invented an array of mythological beings, the subjects of his sculptures as well as his paintings. In *Capricorn,* he used a rigid, frontal compositional style reminiscent of hieratic Egyptian sculpture to create an enigmatic pair of figures — a goat-headed king and fish-tailed queen — as surrogates for himself and Dorothea Tanning, his artist wife.

Another sculptor whose roots are very much in Surrealism is Alberto Giacometti, best known for tall, skeletal bronze figures whose forms look as though they were transformed into pure essence in some great furnace. This Swiss-born artist was an active participant in the early to mid-20th-century Paris art world. Like Max Ernst, he created sculptures that combine human and imaginary elements. By the early 1940s, he arrived at his signature figure, a mystical, introspective being, the gatekeeper of an interior reality. His *The Chariot*, 1950 (Fig. 25, Plate 16), is a definitive example. A tall, linear figure atop a pair of giant wheels, this sculpture recalls an ancient tomb sculpture. Indeed, for many 20th-century sculptors, the ancient world has had irresistible allure, so much so that they seem to commune with it through their art. The chariot driver's elongated torso and limbs, its worked-over, pitted surfaces and spiritualized

aura bring to mind early-Etruscan and pre-Attic Greek effigies. For all such references to antiquity, a decidedly contemporary feeling of anomie — a sense of loss and dislocation — emanates from all of Giacometti's fragile beings. His "everyman" is revealed as irreducible substance, more a soul than a corporeal being. So spare are his figures in form, there is little separation between them and the linear armature on which they are shaped. In such mesmerizing works, Giacometti reduces the body to a few powerful lines and filaments that energize their surrounding space.

Of the many American artists drawn to Surrealism's utilization of mythological themes, none made more original use of this approach than the Japanese-American sculptor, Isamu Noguchi. Noguchi steeped himself in arcane subject matter — in part through set designs for the Martha Graham Dance Company whose programs often dealt with legendary themes — and by the mid-1940s began translating mythological imagery into sculptural forms. Initially, these were curvilinear silhouettes cut from plywood sheets, their interlocking parts held together by gravity and with no bolts or fastenings of any kind. These were succeeded by a series of smooth-surfaced constructions insistently evocative of human anatomy, some carved in balsa wood, others in marble; later, a few were cast in bronze. One of these humanoids, *Avatar* (Fig. 26, Plate 36), from 1947, is a three-legged totemic being, an intricate amalgam of human and illusory shapes reminiscent of the bone, muscle, and tendon imagery favored by many Surrealist painters. Compare its elongated, viscous forms to those in Yves Tanguy's 1947 *At the Risk of the Sun* (Fig. 27), a painting from roughly the same period. As with the amorphous figures in Tanguy's hallucinatory landscape, the body parts in *Avatar* are rife with allusions to bones, muscles, limbs, and breasts. A second Noguchi sculpture from those years, *Night Land*, 1947 (Plate 40), is a masterful fusion of traditional Japanese forms and Surrealist-inspired organic ones. Although the black granite's swelling and scooped-out contours suggest a metaphysical landscape, the well in its smooth surface also recalls the slight depression that contains the ink in a *suzuri*, the ink stone used in Japanese calligraphy.

Like Henry Moore, Isamu Noguchi is represented by a substantial group of sculptures at the Nelson-Atkins — seven in all. Having made sculptures in other materials since

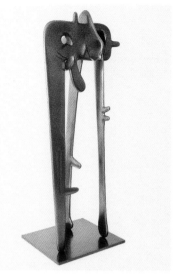

(Fig. 26)
Isamu Noguchi
American, 1904–1988
Avatar, 1947, cast 1988
bronze
78 x 33 x 24 in. (198 x 83.8 x 60.9 cm)
The Hall Family Foundation Collection at
The Nelson-Atkins Museum of Art
30-1998/4

(Fig. 27)
Yves Tanguy, French, 1900–1955
At the Risk of the Sun, 1947
oil on canvas
27 3/4 x 15 3/4 in. (70.5 x 40 cm)
Gift of the Friends of Art
F58-68

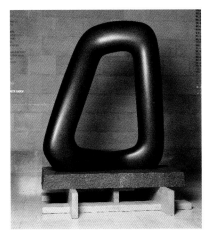

(Fig. 28)
Isamu Noguchi
American, 1904–1988
Six-Foot Energy Void, 1971–1985
Swedish granite
71 1/2 x 61 1/2 x 22 1/2 in.
(181.6 x 156.2 x 57.15 cm)
The Hall Family Foundation Collection at
The Nelson-Atkins Museum of Art
51-1992

(Fig. 29)
Isamu Noguchi
American, 1904–1988
Endless Coupling, 1988
red Swedish granite
94 1/2 x 23 3/4 x 23 3/4 in.
(240.0 x 60.3 x 60.3 cm)
The Hall Family
Foundation Collection
at The Nelson-Atkins
Museum of Art
30-1998/2

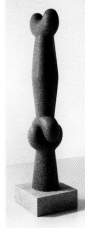

the 1940s, including aluminum and stainless steel, Noguchi returned to direct carving in stone during the last two decades of his long artistic life. By the late 1960s, he divided his time between his Long Island City studio, across the East River from New York, and his studio in the village of Mure outside the city of Takamatsu on Japan's Inland Sea, a major center for quarrying and finishing granite. Stone always had a powerful attraction for Noguchi. Extolling its virtues, he characterized it as "… the most flexible and meaning-impregnated material. The whole world is made of stone. It is nothing new. It is as old as the hills. It is our fundament. … Stone has a quality of durability. It does not pollute. It merely goes back to the earth naturally."[1] As the offspring of a Japanese father, who for a long time had difficulty even acknowledging his son's existence, and an American mother, Noguchi was forever trying to come to terms with his identity. He found that working with traditional Japanese stone carving techniques was an essential way of connecting with his Asian side. Some of Noguchi's massive granite sculptures from Mure are highly individualistic variations on the natural and carved rocks found in traditional Japanese temple gardens. The blocky shapes of his two-part *Fountain,* 1987 (Plate 41), derive from a *tsukubai,* the stone receptacle brimming with purifying water at entrances to Buddhist shrines and ubiquitous in Japanese gardens. The aptly named *Mountain Landscape (Bench),* 1981 (Plate 39), whose contours evoke a craggy natural terrain, also is an inviting place to sit and, if not view nature, then think about it. In doing so, the viewer temporarily inhabits the artist's imaginary landscape. But Noguchi's allusions to historical Japanese art forms are not limited to three-dimensional objects. The sweeping black contours of *Six-Foot Energy Void* (Fig. 28, Plate 42), 1971–85, are reminiscent of boldly brushed Japanese calligraphy. Indeed, the sculpture's smooth, continuous tubular outlines suggest a vigorously executed brush drawing in three-dimensional space.

Early 20th-century Western influences are also apparent in Noguchi's stones, like those of Paris in the 1920s and 1930s, and especially that of Brancusi, whose studio assistant he was in 1926 and 1927. Later sculptures, like *Endless Coupling* (Fig. 29, Plate 38), 1988, a column of repeated vertical units, essentially are Noguchi's homage to the Romanian master. Far beyond such traceable stylistic forces, a defining quality of Noguchi's sculpture is the underlying tension between traditional Asian and mod-

ern Western sensibilities that animate it. Throughout his life much of Noguchi's art was devoted to reconciling these seemingly irreconcilable impulses. On another level, he also was concerned with revealing vital interrelationships between forms in the man-made and the natural worlds. The massive 1985 sculpture *Ends* (Plate 37) is a definitive example of Noguchi's penchant for combining geometric forms and those from nature within a single work. Its four richly expressionistic surfaces, so strongly suggestive of raw nature, combine to create a primal geometric object, a huge hollow square that rests on four large wooden beams. Its interior spaces can be glimpsed only through narrow openings at the corners where the four giant granite slabs meet. *Ends* encloses a mysterious void; perhaps it was Noguchi's meditation on mortality.

Organic Abstraction, a Broad 20th-Century Current

When, in 1942, Jean Arp made the small gilded bronze *Seen and Heard* (Fig. 30), which vaguely resembles a large drop of viscous liquid or a seal on its flippers, he was using an abstract syntax that he, Miró and other Surrealists had employed since the early 1920s. In these images, human and natural world forms seemed to fuse constantly. Organic abstraction, with its ambiguous shapes, rounded contours and continuous unbroken surfaces, quickly became an internationalized style — inspiring such pungent adjectives as "biomorphic" and "free-form"— that indelibly affected sculpture as well as painting. Its roots were in Surrealism, but of another variety than the richly detailed "hand-painted dreams" of Salvador Dali, Tanguy, and René Magritte that revealed troubled, imagined worlds just behind the facade of everyday reality. Nevertheless, the amorphous shapes of sculptures created in this organic mode, however generalized, always have borne some relationship to that reality. They evoke animate and inanimate shapes of the natural world, especially the metamorphic processes of nature in which life forms undergo ceaseless change. So pervasive was this method of abstraction, it was utilized by artists as stylistically diverse as Constantin Brancusi, Alexander Calder, Moore, Barbara Hepworth (Fig. 31) and Noguchi, all represented in the Nelson-Atkins' collection. Of these artists, only the Paris-based Brancusi and Calder were geographically close to the source. Both took what they needed of this abstract style but stayed away

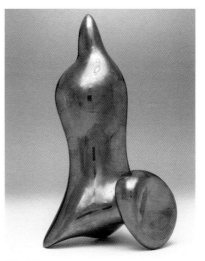

(Fig. 30)
Jean Arp
French, born Germany, 1887–1966
Vue et Entendue (Seen and Heard), 1942
polished copper alloy
13 1/4 in. (33.7 cm)
Gift of the Friends of Art
F63-14

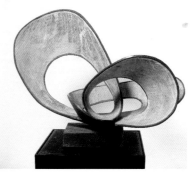

(Fig. 31)
Barbara Hepworth
British, 1903–1975
Forms in Movement (Pavan), 1956; cast 1967
bronze, 3/7
27 x 42 x 22 in. (68.1 x 106.8 x 55.9 cm)
Gift of Rheta Sosland Hurwitt in memory of Louis Sosland
F84-64

15

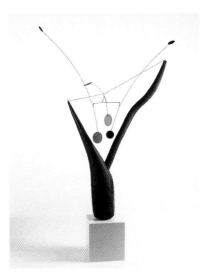

from Surrealism's heavily psychological subtext. In the Romanian-born Brancusi's marble and wood sculptures, basic themes like a woman's head, a soaring bird, or a male torso become elegantly simplified volumes. His objects project a sense both timeless and universal, and thus mark a crucial step in Modernism's progression. His 1925-27 *Portrait of Nancy Cunard* (Fig. 32, Plate 6), the depiction of an elegant if featureless lady, radiates the sophistication of the 1920s French art scene. Cunard, a glamorous young socialite then at the center of the lively Americans-in-Paris artistic milieu, becomes, in Brancusi's eloquent, reductive rendition, an elongated half sphere mounted on a low cylindrical base. A subtly twisted form atop the "head" suggests the lady's chignon. A decade later, the young American sculptor Alexander Calder started using the vocabulary of organic abstraction in his early mobiles, of which the 1937 *Untitled* (Fig. 33, Plate 7) is a classic example. Tremulously suspended in the "V" formed by two smooth-surfaced, worked-over tree limbs is a delicate constellation of yellow, red, and black circular disks, each attached to a thin, spring-steel rod. Their shapes and those of the carved-wood armature come from the same stylistic nexus as the biomorphic forms favored by Miró and Arp. Years later, in free-standing sculptures like the 1967 stabile *Tom's Cubicle* (Plate 8), which suggests a huge, multi-legged insect balanced on spiky toes, Calder continued to use this sinuous form of abstraction, but in the form of steel-plate "cut-outs" bolted to one another and painted black.

No artist outside of Paris made more consistent and personal use of this fluid language than the English sculptor Henry Moore, as is evidenced in the substantial group of his bronzes from 1931 to 1983 at the Nelson-Atkins collection (there are more than 50 Moore bronzes at the Museum, which includes 14 full-scale works and small studies for larger sculptures). Moore systematically evolved his earthy variety of abstraction to describe a world where human and natural forms freely combine as wondrous new entities. Nonetheless, the human form was the core of his art, however cryptically he chose to render it. At the Nelson-Atkins, one of Moore's earliest portrayals of this theme is the 1957 *Seated Woman* (Plate 32), whose angular, bony nude body rests elegantly on a rectangular block. It is about as descriptive as Moore's sculpture ever gets, yet no part of the figure escaped his constant modification of anatomy, and a carefully controlled, consistent level of distortion persists throughout this piece. By the late 1950s, Moore

began to move well away from such relatively literal depictions of the female figure in favor of a more generalized approach. This radical shift is apparent in another *Seated Woman*, this one from 1958-59 (cast 1975; Fig. 34). Here she is a swollen, fecund form — almost a giant pod or life-generating symbol reminiscent of earth mothers from prehistoric Indus Valley earth goddesses to the ripe-bodied Willendorf *Venus*.

No matter how Moore distorts and abstracts the human form and combines it with other elements, it never vanishes from his imagery. It is omnipresent in whole or in part even when inspiration for a particular sculpture comes from a study of inanimate forms. "The human figure is what interests me most deeply," Moore told the writer Philip James in 1966, "but I have found principles of form and rhythm from the study of natural objects such as pebbles, rocks, bones, trees, plants, etc."[2] In bronzes such as *Torso*, 1967 (Fig. 35), and the large horizontal *Reclining Connected Forms*, 1969, his vision of the figure undergoes more drastic change. In both sculptures, what at first resembles primal geological forms like rocks and mountains are, on second reading, alive with allusions to heads, torsos, and limbs. Steadily and inexorably, he moved from his earlier generalized realism into the ambiguous domain of organic abstraction, where he arrived at the trademark style of rounded and pierced forms that he utilized in various combinations and permutations over the next three decades. Within this realm, the interdependence of human, animal and other natural forms increasingly becomes the central theme of his art. Thus, *Torso* is as much a portrayal of massive tree limbs as a rendition of the body. Likewise, while human musculature and bone structure are perceptible in *Reclining Connected Forms*, its configurations allude equally to weathered rocks and ancient caverns shaped by millennia of erosion.

Yet however much Moore's massive sculptures reflect mid-20th-century stylistic attitudes, they also are insistently redolent of history — a history heavily filtered through his own sensibilities. The columnar *Upright Motive No. 9*, 1979 (Plate 29), for example, could be the sculptor's tip of the hat to classicism or its latter-day revival in the herms, those static stone figures in Renaissance and 18th-century formal gardens whose upper bodies emerge from tapered pillars. The languid pose of the woman in *Reclining Figure: Hand*, 1979 (Fig. 36, Plate 27), has countless precedents in art histo-

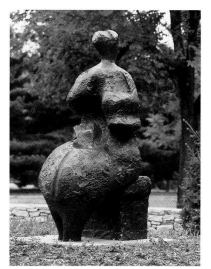

(Fig. 34)
Henry Moore, British, 1898–1986
Seated Woman, 1958–1959
bronze
75 3/4 x 35 x 40 1/4 in. (192.4 x 88.9 x 102.2 cm)
The Hall Family Foundation Collection at
The Nelson-Atkins Museum of Art
66-1986/5

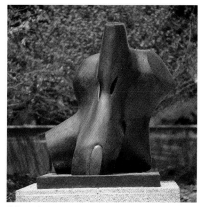

(Fig. 35)
Henry Moore, British, 1898–1986
Torso, 1967
bronze, ed. of 9
43 7/8 x 31 5/8 x 33 in. (111.5 x 80.3 x 83.8 cm)
The Hall Family Foundation Collection at
The Nelson-Atkins Museum of Art
66-1986/24

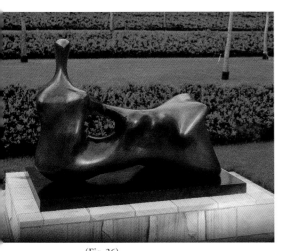

(Fig. 36)
Henry Moore
British, 1898–1986
Reclining Figure: Hand, 1979
bronze
65 x 88 x 52 in. (165.1 x 223.5 x 132 cm)
The Hall Family Foundation Collection
at The Nelson-Atkins Museum of Art
66-1986/3

ry, from Titian to Matisse. For this female sculpture, a sequence of pneumatic volumes and voids, Moore simply appropriated the timeless reclining-nude theme. If from today's more distanced aesthetic, Moore's sculptures, with their constant allusions to primal generative forms seem a bit symbol-heavy, they are, nonetheless, eloquently subjective expressions about universal humanistic concerns: the continuity of life, our relationship to nature, our common history.

Assemblage, or New Life for Old Objects

Less a formal style than an improvisational technique for creating new forms by recombining fragments of old ones, Assemblage was so pervasive here and abroad in the 1950s it had the aura of an international movement. Its intuitive approach to object-making paralleled Abstract Expressionism's free-association process and, like those paintings, the resulting sculptures, composed of many materials juxtaposed in improvised fashion, were a record of journeys into the unknown. Assemblage's origins are in early-20th-century collage, undertaken during Cubism's "synthetic" phase when Picasso and Braque began adhering wine labels, bits of wallpaper, and other materials to their painted canvases, thereby introducing aspects of the real world into them. Many Assemblage sculptures similarly incorporate worn and discarded objects, each with its own history. Like collage, Assemblage is a volatile mix of the deliberate and wholly fortuitous. For many artists, it continues to be a liberating approach to form. So enduring is its premise — a reliance on intuition and the assembling of often-disparate elements — it remains an important sculpture-making process more than 80 years later.

The Nelson-Atkins collection has several exceptional works by American artists who provide an overview of this influential current, including those by Joseph Cornell and Louise Nevelson, two of the first generation of Assemblage's leading exemplars. For both artists, its open-ended techniques offered extraordinary opportunity for highly idiosyncratic poetic expression. From Cornell's modest house in Flushing, New York, came forth an amazing series of small, roughly carpentered boxes — micro-worlds with images drawn from history, legend and the sculptor's own lyrical

fantasies — filled with dime-store objects, astrological charts, faded photographs of long-forgotten ballerinas, opera divas and other esoterica evocative of mysterious times and places. These are Cornell's windows on the strange reality of an imagined interior life, an approach to object-making as intuitive as it is deliberate. This is readily apparent in the Nelson-Atkins' beguiling *A Pantry Ballet (for Jacques Offenbach)*, 1942 (Fig. 37 Plate 10), which features an unlikely lineup of red plastic lobsters as cancan dancers, their lower bodies daintily swathed in transparent lace. Paper doily curtains frame the mirrored "stage" of Cornell's idiosyncratic tribute to the 19th-century composer.

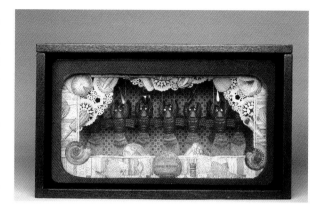

(Fig. 37)
Joseph Cornell
American, 1903–1972
A Pantry Ballet (for Jacques Offenbach), 1942
mixed media
10 1/2 x 18 1/8 x 6 in. (26.7 x 46.1 x 15.2 cm)
Gift of the Friends of Art
F77-34

Many Assemblage sculptures retain the raffish atmosphere of the streets and junkyards from which their parts were gathered. In the late 1940s, Louise Nevelson began haunting New York's produce district, foraging for wooden crates to serve as structural units of her sculptures. Within these she carefully arranged fragments of discarded furniture, parts of banisters, doors, and whatever other useful shards she came upon in her wanderings. Stacking these wooden reliquaries one atop another, she sprayed them a sooty black to create a phantom architecture of wall and towers. Her sculptures at the Nelson-Atkins include the 1973 *End of Day, Nightscape IV* (Fig. 38, Plate 35), a wall-size, shallow-relief constructed of printers' type cases whose gridded interiors contain abstract wooden elements of various sizes and configurations. In these dark, atavistic structures, three-dimensional forms and shadows merge into atmospheric masses.

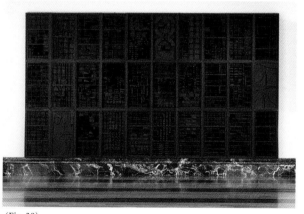

(Fig. 38)
Louise Nevelson
American, born Russia, 1900–1988
End of Day – Nightscape IV, 1973
painted wood
95 x 167 x 7 in. (241.3 x 424.2 x 17.7 cm)
Gift of the Friends of Art
F74-30

Far different in mood from these serene contemplative images are John Chamberlain's violently twisted metal automobile carcasses. A classic example is the 1961 *Huzzy* (Fig. 39, Plate 9). Like Cornell and Nevelson, his subject matter — car bodies salvaged from automobile graveyards — mirrors 20th-century throwaway culture. He

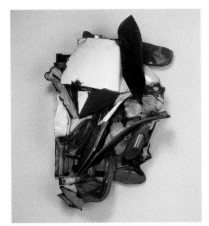

(Fig. 39)
John Chamberlain
American, b. 1927
Huzzy, 1961
painted and chromium-plated steel with fabric
54 x 33 x 21 in. (137.2 x 83.8 x 53.3 cm)
Gift of Mrs. Charles F. Buckwalter in memory
of Charles F. Buckwalter
F64-8

(Fig. 40)
Franz Kline, American, 1910–1962
Turin, 1960
oil on canvas
80 3/8 x 95 1/2 in. (204.1 x 242.6 cm)
Gift of Mrs. Alfred B. Clark through
the Friends of Art
F61-23

twisted, pounded and otherwise shaped these sheets of battered metal into aggressive talismans, *memento mori* of urban violence and highway death. Their turbulent shapes, serrated edges, and slashes of color recall the sweeping forms of Abstract Expressionism's imagery. Compare the turbulence of *Huzzy* to the gestural shapes in *Turin* (Fig. 40), the Nelson-Atkins' monumental 1960 Franz Kline painting executed in thick, black brush strokes. Aside from the broad, slashing forms they have in common, both works reflect a richly expressive sensibility and project fierce energy.

In many of their sculptures, both Jim Dine and Nancy Graves elaborate on the concept of Assemblage by casting "found" and invented objects in bronze and affixing them to armatures that are integral parts of the sculpture. In *The Crommelynck Gate with Tools* (Plate 11), 1984, Dine incorporated handtools within the bronze gate's restless linear design. While he cast some from actual objects, others are his idiosyncratic variations on these utilitarian forms that include elongated and twisting hammers, oversized wrenches and "soft-handled" axes. The gate's outlines were inspired by the curvilinear iron gate at the entrance to Aldo Crommelynck's print-making workshop in Paris. This motif, echoed in several of Dine's paintings and prints of the mid-1980s, is his tribute to that legendary master printer with whom he collaborated on many graphics projects. Like Dine's gate, Nancy Graves' assemblages are fragile traceries in space. Her *Zaga*, 1983 (Plate 17), is a buoyant configuration of seemingly unrelated objects — metal pipes, part of a wheel, a few milkweed pods and plant leaves — cast in bronze and so delicately welded at points along their edges that they seem barely to touch.

An Industrial Aesthetic: The Material World as Art

Throughout the 20th century, the deeply ingrained American belief in the power of technology found rich expression, first in painting and, by the mid-1950s, in sculpture. In the early decades, this belief paralleled the dramatic rise of industry and technology, shaping a cultural aesthetic that celebrated the machine and the notion of progress. It also engendered a new urban iconography, characterized by clear-edged depictions of impressive factories, towering skyscrapers, bridges, ocean liners, giant dams, and turbines. In painting, Precisionism was the most significant of these early movements during the 1920s and into the mid-1950s. Enthralled by such heroic American themes, its artists, including Joseph Stella, Charles Sheeler (Fig. 41), Charles Demuth, and Ralston Crawford, idealized them in their imagery. Some Precisionists, like Sheeler, also were brilliant photographers, famous for clear-edged camera images of efficient factories and the brave new metropolis.

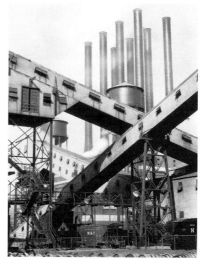

(Fig. 41)
Charles Sheeler
American, 1883–1965
Ford Plant – Criss-Crossed Conveyors, 1927
vintage gelatin silver print
9 1/2 x 7 1/2 in. (24.1 x 19 cm)
The Hallmark Photographic Collection

Although the strict Precisionist view of America was eclipsed in the 1950s by the flat-out emotionalism of Abstract Expressionism, some aspects of its underlying machine aesthetic not only survived but flourished — this time in sculpture, not painting. In that decade, a number of young American sculptors seeking new expressive means turned to industrial materials and processes. For them, fabricating constructions from sheets of copper and steel planes and rods offered an exhilarating way to arrive at a new form and an appealing alternative to wood and stone carving and bronze casting. This passion for direct welding soon took on its own aesthetic as sculptors like David Smith, George Rickey, Theodore Roszak, Richard Lippold, and Richard Stankiewicz became proficient and extraordinarily inventive in its techniques. From today's perspective, Smith remains the most influential of these sculptors. His forms, for all their abstraction, reflect immediate surroundings and derive as much from farm machinery, wagons and other vehicles around the artist's Bolton Landing studio in upstate New York as from pictographic imagery used by many of his painter friends. Smith's 1964 *Wagon III* (Fig. 42, Plate 54) at the Nelson-Atkins is an especially fine example of his felicitous synthesis of real objects and invented forms. A flat and linear construction, it consists of a long horizontal bar to which are affixed a sequence of lightly defined circular, diamond, and asterisk shapes. The

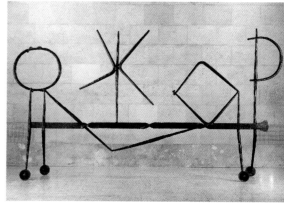

(Fig. 42)
David Smith
American, 1906–1965
Wagon III, 1964
welded and cast steel
100 x 163 x 30 in. (254 x 414 x 76.2 cm)
The Hall Family Foundation Collection at
The Nelson-Atkins Museum of Art
27-1981

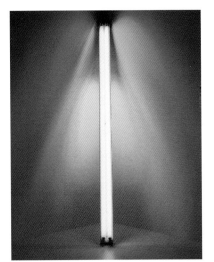

(Fig. 43)
Dan Flavin
American, b. 1933
Untitled (to the real Dan Hill), 1978
blue, green, yellow and pink fluorescent light
96 x 5 1/4 x 9 in. (243.8 x 13.3 x 22.9 cm)
Gift of The Guild of the Friends of Art
F85-26

(Fig. 44)
Carl Andre
American, b. 1935
Aluminum and Magnesium Plain, 1969
aluminum and magnesium, 36 plates
3/8 x 72 x 72 in. (1.0 x 182.9 x 182.9 cm)
The Patsy and Raymond Nasher Collection at
The Nelson-Atkins Museum of Art, lent by
the Hall Family Foundation
37-1991/1 a-nn

entire playful contraption rests on four small wheels. Although an artist who came out of Assemblage and never lost contact with its improvisational approach, Smith later created an even more abstract approach to form. His effect on younger artists was and remains profound. In addition to innovative essays in stainless steel, he opened the door for many of his fellow artists to the expressive qualities of pure geometry.

Among those influenced were a number of young sculptors, who, in the early 1960s were described as Minimalists. Their efforts consisted of sharp-edged, industrial-looking planes and volumes realized in materials as varied as galvanized steel, stainless steel, glass, sheets of colored plastic and fluorescent light tubes. This style is especially well documented at the Nelson-Atkins, where each of the movement's major artists — Donald Judd, Dan Flavin, and Carl Andre — is represented by significant works. Although the irreducible geometry of their sculptures reflects the purism of many paintings of that period — specifically those of Ellsworth Kelly, Frank Stella, and Agnes Martin, all represented at the Nelson-Atkins — Minimalism was and remains an essentially sculptural concept.

Coinciding chronologically with Pop Art and aesthetically its polar opposite, Minimalism was an incisive reaction against what its exemplars deemed the emotional excesses of Abstract Expressionist painting, whose artists relied on intuition and fortuitous accidents in their quest for new form. These sculptors, some of whom began their careers as painters (Judd, Flavin), rejected such uncertainties. In fact, the immaculately finished surfaces of their objects revealed little, if any, trace of the artist's hand and were never a record of the creative journey. For the Minimalists, the finished object already existed in their minds to such a degree that the next logical step was to make a detailed drawing that specified its materials and finish, then hand this to a fabricator who would oversee production of the object. Although these pristine works in various industrial materials embodied a rarefied aesthetic of elegant proportion and equilibrium, they were far from sterile objects; many demonstrated imaginative use of color, transparency and reflection. Flavin's elegantly linear, fluorescent tube sculptures (Fig. 43) saturate the walls and corners where they are installed with radiant color. Some Minimalist works were made to be shown as single units, others as repeated components of a series. These are sculptures without bases. Some, like Andre's *Aluminum and Magnesium Plain* (Fig. 44), 1969, were meant to be exhibited

directly on the floor, while the stainless steel and amber Plexiglas boxes of the 1968 *Large Stack* (Fig. 45, Plate 20) by Donald Judd were designed for installation, one above the other at specified intervals, on a wall whose expanse becomes part of the composition.

Often viewed somewhat apart from the Minimalist trinity of Judd, Andre and Flavin, although sharing their commitment to pure form, Sol LeWitt has evolved a readily identifiable vocabulary of geometric shapes in his wall drawings and sculptures. For all their purity, his gridlike structures, while based on mathematical progressions, are anything but remote or formulaic in their effect. Rather, as the towering 16-foot, 6-inch ziggurat, *1 3 5 7 9 11* (Fig. 46, Plate 21), 1994, reveals, they are atmospheric volumes of indeterminate depth whose configurations of white painted metal bars change magically in an interplay of light and shadow. Like all LeWitt's work, this sculpture is based on principles of harmonious proportion and the constant interaction of its elements. Its fabrication represents a major variation on a favorite LeWitt motif — the open cube — identified with his art for almost five decades.

The imagery of two other artists represented at the Nelson-Atkins offers more interpolations on the industrial theme. Mark di Suvero and Siah Armajani present the industrial concept in a considerably less hermetical way. Like David Smith, di Suvero began his career as an Assemblage artist, an avid recycler, not only of discarded barrels, broken chairs, and massive timbers rescued from demolition sites, but of rusted boilers and salvaged boat prows. These found their way into his spirited constructions, some that revolve like giant whirligigs, others that encourage visitors to sit or lie down on their suspended platforms and swings. Since the late 1960s, di Suvero's sculptures have grown larger but simpler. He began constructing them of I-beams, welding their massive diagonal elements together at vortexes he called "knots" and, after completion, investing them with romantic titles. His 1991 *Rumi* (Plate 12) at the Nelson-Atkins, named after a 13th-century Persian Sufi poet whose widely admired verses convey a state of meditative rapture, is a soaring, orange-painted configuration of huge steel beams. For all its geometric clarity, *Rumi* is anything but static. It is strongly gestural from every vantage, so much so that its angular forms, for all their weightiness, seem to gyrate — even more so as the visitor walks around it.

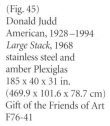

(Fig. 45)
Donald Judd
American, 1928–1994
Large Stack, 1968
stainless steel and
amber Plexiglas
185 x 40 x 31 in.
(469.9 x 101.6 x 78.7 cm)
Gift of the Friends of Art
F76-41

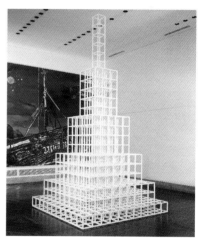

(Fig. 46)
Sol LeWitt
American, b. 1928
1 3 5 7 9 11,
conceived 1994; fabricated 1996
baked enamel on aluminum
16 ft. 6 in. x 8 ft. 8 in. x 8 ft. 8 in.
(5 x 2.6 x 2.6 m)
The Hall Family Foundation Collection at
The Nelson-Atkins Museum of Art
2-1996

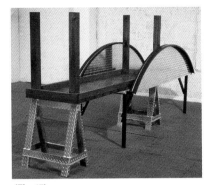

(Fig. 47)
Siah Armajani
American, born Iran, 1939
Elements #16, 1985–88
steel, aluminum, wood and paint
68 1/2 x 139 1/4 x 40 in. (174 x 353.7 x 101.6 cm)
Gift of the artist in honor of Martin and
Mickey Friedman
F98-25/1 a-d

(Fig. 48)
Siah Armajani
American, born Iran, 1939
Irene Hixon Whitney Bridge, 1988
Gift of the Minneapolis Foundation/Irene
Hixon Whitney Family Foundation, and
Wheelock Whitney, with additional support
and services from the Federal Highway
Administration, the Minnesota Department of
Transportation, the City of Minneapolis, and
the National Endowment for the Arts

Coincidentally, there is a second, if unrelated, manifestation of Persian sensibility at The Nelson-Atkins Museum of Art, represented by the work of the Iranian-born sculptor, Siah Armajani, who has lived in St. Paul, Minnesota, since 1960. But the sources of his industrial imagery are less in traditional Persian culture than 19th-century feats of American engineering, such as space-spanning steel bridges whose tensile forms he regards as poetic. His 1985–88 *Elements #16* (Fig. 47, Plate 4), in fact, was an early effort to arrive at the form for a 375-foot pedestrian bridge he was commissioned to design that would span 16 lanes of state highway traffic near downtown Minneapolis. For this project, he studied an earlier span, an 1888 bridge across the Mississippi River, due to be dismantled and replaced. Armajani's final design for the bridge, the one constructed in 1988 (Fig. 48), consists of two sets of parabolic trusses, one the upside-down version of the other, which overlap at the center like a symbolic handshake across the highway.

In and Out of Reality: Objects and Figures

American Realism, all but marginalized in the mid-1940s by the heady new current of Abstract painting, re-emerged suddenly in the late 1950s in the unlikely context of Pop Art. This new movement's raucous imagery was freely borrowed from sources as diverse as supermarkets, sports events, movies and television, and the never-never land of advertising. As a younger artistic generation's irreverent reaction to Abstract Expressionism's "high-art" precepts, Pop wryly reflects the forms and values of the consumer-oriented society that spawned it by focusing on ubiquitous objects and everyday events. No mundane article or image was too unworthy to be ennobled. In Andy Warhol's 1962 painting *Baseball*, Roger Maris is heroically at bat, over and over again, in a blurry succession of contiguous black-and-white silk-screened images, like those on a flickering TV screen. In place of the traditional studio still life with a vase of flowers, fruit bowl, and guitar emerges Tom Wesselmann's three-dimensional painting *Still Life No. 24* (Fig. 49), complete with renderings of canned goods, a cigarette pack, an ear of buttered corn and an overlay of gauzy curtain fabric. In Pop's other-side-of-the-mirror realm, familiar objects take on a heightened, if skewed, reality.

When it comes to transforming ordinary objects and giving them new identity, no one does this better or more consistently than Claes Oldenburg. In his world of parallel reality, clothespins, electric fans, three-way plugs, vacuum cleaners and musical instruments assume an eerie anthropomorphism. One of Pop Art's founding virtuosos, he is represented at the Nelson-Atkins by three sculptures made during a 30-year period. The earliest, *Switches Sketch* (Fig. 50, Plate 46), is a 1964 portrayal in shiny red-orange vinyl of an electric light switch. In this transformation, a familiar, near-invisible household object inexplicably becomes a huge, soft, insistent entity. By drastically changing a familiar object's scale and materials, as in his light switch, Oldenburg virtually reinvents it. While his forms are based on real objects, whatever ideas he intends to express are embodied in his versions of them. Thus, he says, a sculpture derived in this manner, "is not a copy and not an attempt to render something. It's not realism or naturalism, in that sense. It's a re-construction."[3] In short, a new entity.

Fast forward to 1992 for two more examples: first, *Soft Saxophone, Scale B* (Plate 43), a "hard sculpture" of resin-stiffened cloth whose curved form and dangling keys are subliminally reminiscent of a human vertebrae. Then came *Shuttlecocks* (Fig. 51, Plate 44), a vast outdoor work created collaboratively with Oldenburg's wife, Coosje van Bruggen. It is the most space-consuming sculpture at the Nelson-Atkins and the largest commissioned project by the pair anywhere to date. If, in 1989, the Nelson-Atkins' outdoor installation of the Henry Moore bronzes elicited appreciative community response, the advent of *Shuttlecocks* next to them six years later in a newly designated Kansas City Sculpture Park triggered a wide range of reactions, from unalloyed enthusiasm to righteous indignation. Controversy notwithstanding — or perhaps because of it — these alien arrivals soon attracted numerous visitors eager

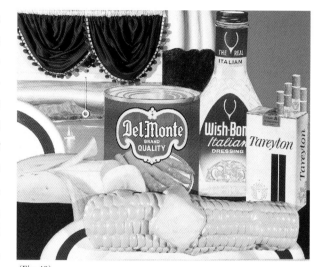

(Fig. 49)
Tom Wesselmann
American, b. 1931
Still Life No. 24, 1962
Acrylic polymer on board; fabric curtain
48 x 59 7/8 in. (122.0 x 152.1 cm)
Gift of the Guild of the Friends of Art
F66-54

(Fig. 50)
Claes Oldenburg
American, born Sweden, 1929
Switches Sketch, 1964
vinyl and dacron
47 x 47 x 3 5/8 in. (119.4 x 119.4 x 9.2 cm)
Gift of the Chapin Family in memory of Susan Chapin Buckwalter
65-29

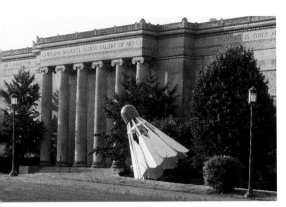

(Fig. 51)
Claes Oldenburg,
American, born Sweden, 1929
Coosje van Bruggen
American, born The Netherlands, 1942
Shuttlecocks, 1994
aluminum and fiberglass
4 elements:
19 ft. 2 1/2 in. x 17 ft. 5 in. x 15 ft. 11 3/4 in. (5.9 x 5.3 x 4.9 m)
20 ft. x 15 ft. x 15 ft. 11 3/4 in. (6.1 x 4.6 x 4.9 m)
17 ft. 11 3/4 in. x 17 ft. 5 in. x 15 ft. 11 3/4 in. (5.5 x 5.3 x 4.9 m)
18 ft. 3 1/2 in. x 18 ft. 10 in. x 15 ft. 11 3/4 in. (5.6 x 5.7 x 4.9 m)
Purchase: acquired through the generosity of the
Sosland Family
F94-1/1-4

(Fig. 52)
Ursula von Rydingsvard
American, of Polish descent, b. 1942
Three Bowls, 1990
cedar and graphite
112 1/2 x 190 x 96 in. (285.8 x 482.6 x 243.8 cm)
Purchase: acquired through the generosity of
the Hall Family Foundation, the George H. &
Elizabeth O. Davis Fund, G. Kenneth Baum and
Judy and Alan Kosloff
F99-9

to make up their own minds and have their pictures taken standing next to these improbable but compelling objects. Visitors come to see and argue about four enormous, casually deployed white-feathered badminton "birds," one in front of the building and three to the south of it, which look left over from a game played by giants. Observers quickly grasp the idea Oldenburg and van Bruggen posit in the design. As in Oldenburg's preliminary drawings and models for the piece (Plate 45), the south lawn's 17-acre green rectangle and the land north of the Nelson-Atkins is, metaphorically speaking, transformed into a badminton court, with the Museum building blurrily "morphed" into a net.

If Oldenburg and his "Popster" confreres could elevate mundane objects to major themes, and, in the process, comment ironically on aspects of late-20th-century culture, familiar forms were vehicles that generated far different ideas for another generation of artists. Sculptors stylistically as varied as Ursula von Rydingsvard, Magdalena Jetelova, and Martin Puryear found such ordinary forms could be invested with deeply expressive, even mystical character. Many of von Rydingsvard's wooden sculptures resembling giant spoons, boxes, shovels and washboards are persistent images mined from childhood memories of the camps for displaced persons in Germany where she and her family spent many years during World War II. Constructed of cedar timbers that she saws, carves, laminates and darkens with graphite and oil, the sculptures are surrogates for the domestic paraphernalia that surrounded her family in its austere barracks. In *Three Bowls* (Fig. 52, Plate 55), 1990, we are confronted by a trio of towering, raw-surfaced vessels that look as though they were just unearthed from some unknown place. For von Rydingsvard, the primal bowl is a frequently repeated theme that appears in many variations. Asked why she uses the object so often, she says the simple, ubiquitous bowl shape allows endless interpretations; more than a container, it is a vessel expressive of a wide range of feelings. "A bowl can be everything" von Rydingsvard muses cryptically, "sometimes benign and nurturing, sometimes harsh and aggressive. It is a replica of everything that has consequences."[4]

In many ways, Magdalena Jetelova's gargantuan 1988 *Tisch* (*Table*) (Fig. 53, Plate 19) is first-cousin to von Rydingsvard's rudimentary domestic objects, rooted as it is in a somber and somewhat similar central European mystique. Born in Czechoslovakia, Jetelova moved to West Germany in 1985. Her battered table, a massive wood form, exudes a mood of anxiety and threat. It is unnerving suddenly to come upon this huge, overturned object in the Museum, heavy legs askew, thick top heavily scarred and partially destroyed. It looks like an object shoved against the gallery's pristine white wall, a prop from some violent drama that has just played out.

A far different feeling, one of cool order and controlled complexity, emanates from Martin Puryear's wood sculptures, whose sinuous forms move in and out of reality. Elegantly crafted objects, with elemental configurations and smooth, continuous surfaces, they are a late-20th-century variation on the venerable organic abstraction mode. Like the sculptural work that emerged out of that fluid approach to form, Puryear's work abounds with allusions to both living and inanimate forms while retaining an aura of ambiguity. As his sculptures go, *Plenty's Boast*, 1994-95 (Fig. 54 Plate 47), is a descriptive example, full of tantalizing clues about its subject matter but, at the same time, teasingly non-specific. Although its carefully modeled conical shape simultaneously suggests a cornucopia, a giant morning glory and an old phonograph horn, according to Puryear, it could be any, all or none of them.[5] The decision is the observer's.

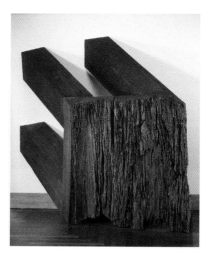

(Fig. 53)
Magdalena Jetelova
Czechoslovakian,
b. 1946
Tisch (Table), 1988
sipo wood
114 in. x 106 1/4 x 61 in.
(289.6 x 269.9 x
154.9 cm)
Gift of the Nerman
Family Collection
F94-35

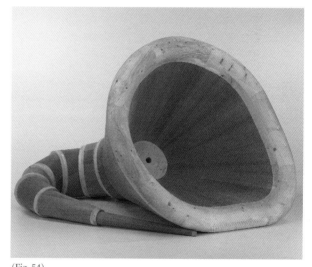

(Fig. 54)
Martin Puryear
American, b. 1941
Plenty's Boast, 1994–1995
red cedar and pine
68 x 83 x 118 in. (172.7 x 210.8 x 134.6 cm)
Purchase: the Renee C. Crowell Trust
F95-16 A-C

27

The Human Figure as a Modernist Constant

Arguably, all sculptures, whatever their degree of abstraction, are somewhat anthropomorphic because, unlike paintings, they are a palpable presence that shares the viewer's space. Even during Modernism's most uncompromising embrace of absolute abstraction, the theme of the human figure survived by assuming many guises that reflected changing philosophical and stylistic attitudes. Although sidelined from time to time by one successive style or another, the figure constantly reemerges. Like the "everyday-object" motif, it seems to have undergone every conceivable variation and permutation. Whether rendered with detailed exactitude or barely indicated with a few tentative lines, the human figure remains a compelling, ever-renewable subject artists imbue with countless meanings. The Nelson-Atkins' range of figurative sculptures is varied and extensive. In fact, the human form is a virtual *leitmotif* of the collection, encompassing a variety of stylistic approaches from the end of the last century to the end of this one. Still, if we consider some recent sculptures, what soon becomes clear is that most resist easy thematic and stylistic categorization.

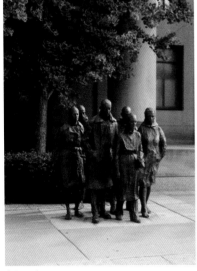

(Fig. 55)
George Segal
American, b. 1924
Rush Hour, 1983; cast 1995
bronze
64 1/2 x 20 x 19 in. (163.8 x 50.8 x 48.3 cm)
The Hall Family Foundation Collection at
The Nelson-Atkins Museum of Art
25-1995/1-6

Among the most descriptive of the late-20th-century works is *Rush Hour*, 1983 (cast 1995) (Fig. 55, Plate 52), by George Segal, whose expressive treatment of the figure is in many respects reminiscent of Rodin's late-19th-century interpretations. The major difference, of course, lies in philosophical approach. Segal's empathetic blue-collar factualism, based on ordinary people and mundane events, could not be more opposite in feeling to his illustrious predecessor's heroic visions of the human form. The 100-plus years that separate these artists have seen extraordinary variations on this theme, even to where the human subject itself all but dissolves into abstraction. Although he belonged to the youthful generation of Pop Artists that purist Abstractionists regarded as aesthetic iconoclasts, Segal's imagery, unlike his contemporaries in the movement, always was more responsive to than ironic about his subjects. In that sense, although intimately identified with the genesis of the Pop Art movement, because of his Expressionist bias, he also was outside it. As in all Segal's urban vignettes, the figures in *Rush Hour* are as isolated from each other as they are

from the observer. In this allegory of isolation and loneliness, they stand at an invisible street crossing, waiting for the light to change — or something else to happen. Although he lived and worked for a long time in rural New Jersey, Segal identifies strongly with New York, where he was born and raised and constantly visits. Its streets, he says, especially fascinate him, "with their crowds of people walking, contained in their own mental boundaries — everybody holding themselves private from everyone else — yet everyone is clustered in these crowds." Commenting on *Rush Hour*, he adds, "I guess I'm indulging my voyeurness about the city."[6] If Rodin exalted the nude body, Segal's attitude about the human form is obdurately anti-heroic. Constructing his figures in wet plaster directly on his subjects, usually patient friends or relatives, he radically modifies the plaster shell's contours as it hardens, shaping a fold here, emphasizing the line of a neck or shoulder there, so the model's body is a mere point of departure for the final work. The insides of the plaster chrysalis — the molds from which his figures are cast — bear the evidence of this rapid, intuitive form-building technique.

Segal is not the only artist in the Museum's collection whose sculptures are made directly on the figure — as opposed to traditional methods of modeling in clay or carving in wood or stone. Some highly individualistic variations on this casting technique characterize the work of artists as philosophically and aesthetically diverse from Segal — and from one another — as Duane Hanson, Magdalena Abakanowicz and Judith Shea. Through his uncannily hyper-realistic representations of ordinary people, Hanson contributed to Pop's ethos without being part of its New York inner circle. Where Segal seeks universal meaning in urban parables, Hanson's focus was on the reality of the moment. His polyester-and-fiberglass figures are rendered with such exactitude, they force the viewer to question the very notion of reality. His *Museum Guard*, 1975 (Fig. 56, Plate 18), is an uncompromising simulacrum where no detail of the model is too unimportant to be ignored. The guard is an all-the-more-insistent presence when installed alongside more "expected" works of art in a gallery.

Isolated from one another psychologically, like Segal's static pedestrians but far more generalized in form, are Polish-born Magdalena Abakanowicz's headless effigies. Her

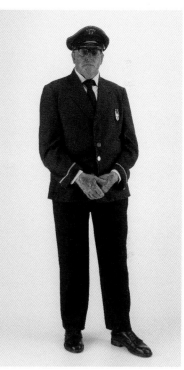

(Fig. 56)
Duane Hanson
American, 1925–1996
Museum Guard, 1975
polyester, fiberglass, oil, and vinyl
69 x 31 x 13 in. (175.3 x 78.7 x 33 cm)
Gift of the Friends of Art
F76-40

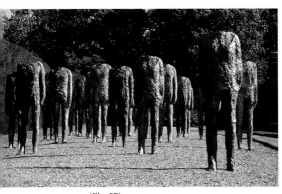

(Fig. 57)
Magdalena Abakanowicz,
Polish, b. 1930
Standing Figures (*Thirty Figures*), 1994–1998, as
installed at Yorkshire Sculpture Park, Yorkshire,
England. To be installed in Kansas City
Sculpture Park in June 1999.
bronze
72 1/8 x 21 5/8 x 13 1/4 in. (175 x 55 x 97 cm)
The Hall Family Foundation Collection at
The Nelson-Atkins Museum of Art
16-1999 a-dd

(Fig. 58)
Judith Shea
American, b. 1948
Study for *Storage*, 1999
watercolor on paper
22 3/4 x 30 1/4 in. (57.8 x 76.8 cm)
Gift of the artist
Proposed sculpture: *Storage*, 1999
bronze
approximately 9 x 8 x 4 ft. (2.7 x 2.4 x 1.2 m)
The Hall Family Foundation Collection at
The Nelson-Atkins Museum of Art
34-1998/3

spectral *Standing Figures* (*30 Figures*), 1994–1998 (Fig. 57, Plate 1), invites many interpretations, exactly the free-association reaction she desires. They might be supplicants, war victims, ancient beings in wordless communion or souls in limbo awaiting final judgment. As to the origins and meaning of her groups of indeterminate figures, her response is appropriately ambiguous, even a bit Delphic in its tantalizing vagueness: "A crowd of people or birds, insects or leaves, is a mysterious assemblage of variants of a certain prototype. A riddle of nature's abhorrence of exact repetition or inability to produce it."[7] Each figure resembles the others in that all are cast from the same basic form, but their surfaces differ in the cloth wrappings and other textures she applies during the bronze casting process. The effect of this standing phalanx is magical. When seen from one side, its forms are assertive volumes; from another, shadowy masses.

For Judith Shea, the figure has long had strong ancestral connotations, and she uses it lyrically as a way to commune with the past, not only a shared past of antiquity but her own artistic history. For some 20 years she has conducted a dialogue with long-vanished cultures through her sculptures, some of whose forms allude to ancient Egypt and the classical world. These oblique "quotes" from antiquity take on immediacy in her art, in the way she renders and then juxtaposes them with distinctly contemporary ones. A recent example is the 1999 Study for *Storage* (Fig. 58 Plate 53), the components of which are based on sections she modified from her earlier sculptures. *Storage* consists of two whole and two partial columnar female figures, one of them a new, highly stylized self-portrait. Adjacent to these is a standing male symbolized by an empty overcoat, a favorite Shea motif. Prior to casting her figures in bronze, she forms them by using felt saturated with hot wax, a pliable medium that produces lightweight shells whose contours and surfaces she continues to refine, even after the shell material has stiffened. In the Kansas City Sculpture Park, four elements of this sculpture, three female and one male figure who, Shea says, might represent her past,[8] are "leaned" against a high limestone wall as though they are indeed in storage, while the new figure of herself, the future, stands on its own.

Sometimes the sources of figuration in works at the Museum are well outside Modernism's mainstream, as in Alison Saar's *Subway Preacher* tableau (Fig. 59, Plate

51). This fine example of Assemblage from 1984 incorporates the figure using carved wood, tin, paper, pottery, lace, and carpeting. The artist probes another kind of reality, a mystical one based on images derived from black storefront churches, refracted through her inventive sensibility. Inspired by a street preacher Saar saw frequently while riding the subway, this sculpture's roughly shaped, doll-like figure, flanked by two huge bouquets of artificial flowers, stands on a pedestal against a painted blue sky, perhaps symbolizing, says Saar, "the improbable combination of the subway and heaven in New York."[9]

Other examples underscore the point that late-20th-century renditions of the human body embrace radically disparate approaches. Consider the stylistic chasm between Hanson's obsessive literalism and Joel Shapiro's anthropomorphic geometry. There are many instances of artists represented at the Nelson-Atkins who radically simplify familiar forms to the point of abstraction — among them Arp, Moore, Noguchi, and Smith earlier in the century, Puryear and von Rydingsvard more recently. Shapiro's approach is the opposite. His realizations of the human form emerge from abstraction. Beginning with a formal vocabulary of elongated rectangular solids, he connects, cantilevers, and counterbalances them in various energetic configurations. The results are a dazzling succession of animated bronze personages, like the stretching figure portrayed in his 1991 *Untitled* (Fig. 60).

(Fig. 59)
Alison Saar
American, b. 1956
Subway Preacher, 1984
wood, canvas and mixed media
86 x 56 x 31 in. (226.1 x 142.2 x 78.7 cm)
Purchase: acquired through the generosity of Michael Weaver, M.D., Paul and Bunni Copaken, Larry and Stephanie Jacobson, and the Nelson Gallery Foundation
F93-23 a-l

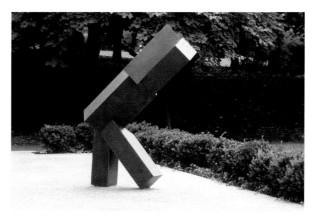

(Fig. 60)
Joel Shapiro
American, b. 1941
Untitled, 1991
bronze
78 1/8 x 59 x 27 in. (198.5 x 149.9 x 68.6 cm)
The Hall Family Foundation Collection at The Nelson-Atkins Museum of Art
50-1992/3

Modern Sculpture's Future at the Nelson-Atkins

While the Nelson-Atkins sculpture collection has grown dramatically during the past 10 years, with many distinguished acquisitions made through purchase and gifts, it is still in its formative stage and will require continued development in many areas to realize the Museum's important goal of documenting the evolution of Modernism. This involves continued acquisition of crucial early-20th-century Modernist works, sculptures by contemporary masters, and key examples by a younger generation of artists, many on their way to master status. Thanks to the Modern Sculpture Initiative, there is considerable momentum for continuing this essential process. The prospect of a major addition to the present Museum building adds further impetus to realizing this goal as additional gallery space for modern art will be part of the proposed construction. With such expansion, development of new sites within the Sculpture Park for works from the permanent collection and special exhibitions will help increase the critical mass of major sculptures on view outdoors and further emphasize the crucial connections between them and other modern works of art inside. Indeed, the close thematic and formal relationships between many of the outdoor objects and works of historical art on view inside the Museum become increasingly clear as the Nelson-Atkins' modern sculpture collection grows. Twentieth-century artists long have absorbed the lessons of the past as they evolved their individualistic imagery. By helping visitors to perceive such connections, The Nelson-Atkins Museum of Art moves still closer to presenting Modernism as part of a vital continuum, not as an isolated phenomenon. As even a casual consideration of these relationships makes clear, today's Modernism is tomorrow's history.

Martin Friedman
Director Emeritus, Walker Art Center

[1] *Isamu Noguchi*, Sam Hunter (New York: Abbeville Press, 1978), p. 121
[2] *Henry Moore on Sculpture*, Philip James (London: McDonald & Co., 1996), p. 70
[3] Unpublished interview with Martin Friedman, November 1996
[4] Unpublished interview with Martin Friedman, August 1997
[5] Conversation with Martin Friedman, January 1999
[6] Unpublished interview with Martin Friedman, January 1996
[7] *Magdalena Abakanowicz*, Barbara Rose (New York: Harry N. Abrams, Inc., 1994), p. 128
[8] Conversation with Martin Friedman, January 1999
[9] Conversation with Martin Friedman, January 1999

Artists and Works

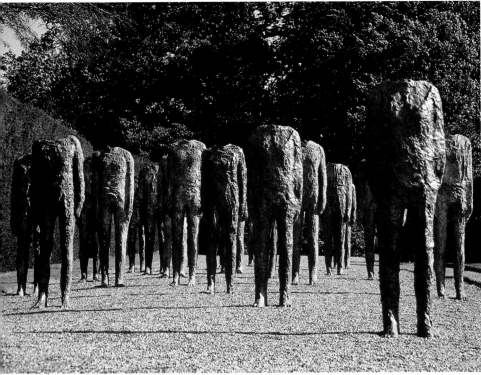

Plate 1
Standing Figures (Thirty Figures), 1994–1998, as installed at Yorkshire
Sculpture Park, Yorkshire, England. To be installed in Kansas City
Sculpture Park in June 1999
bronze
72 1/8 x 21 5/8 x 13 1/4 in. (175 x 55 x 97 cm)
The Hall Family Foundation Collection at
The Nelson-Atkins Museum of Art
16-1999 a-dd

Magdalena Abakanowicz
Polish, b. 1930

Magdalena Abakanowicz first gained international recognition as a weaver in the 1960s. Traveling to the South Pacific in 1970, where she saw ceremonial masks and carved wood figures, Abakanowicz began producing sculptural fragments such as disembodied heads, torsos with no limbs and headless bodies, incorporating materials such as burlap, rope, string and cotton.

Abakanowicz forms the personages in works such as *Standing Figures (Thirty Figures)* by wrapping a model in plaster-soaked burlap that soon hardens into a thin, textured shell. Sculptures intended for outdoor display are cast in bronze. The characters in any group closely resemble each other, but the surface of each figure is unique.

Standing Figures invites many readings, which the artist welcomes. The characters could be war victims, suggesting the German invasion of Poland in 1939, in which Abakanowicz saw her mother's arm torn from her body by Nazi gunfire. Alternatively, the figures may hearken to happier parts of the artist's childhood. The empty figures bring to mind hollow tree trunks, recalling the woods where she played, as well as small wood and clay effigies of creatures from folktales that she made. In still other interpretations, the figures suggest supplicants awaiting some final judgment, or primordial beings in silent rituals. *JM*

Alexander Archipenko
American, born Russia, 1887–1964

Born in Kiev, Russia (present-day Ukraine), Alexander Archipenko arrived in Paris in 1908 just as the artistic movement known as Cubism took form. The son of an engineer and grandson of an icon painter, Archipenko brought to his work a refined and precise sensibility. He united Cubist investigations of fragmented forms and solidified space with his own concerns for the dynamics of movement. The taut, opposing diagonals of Archipenko's *Statue on Triangular Base* create a syncopated, rhythmic flow that moves from the triangular base, through the streamlined body and out the head and upraised arm. The unexpected interplay between concave and convex forms intensifies the work's dynamism. *JS*

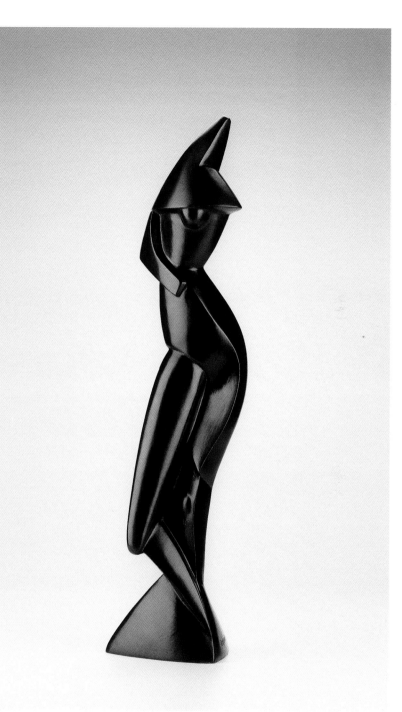

Plate 2
Statue on Triangular Base, 1914
bronze
height 29 7/8 in.
(75.9 cm)
Gift of Mrs. Louis Sosland
F77-24

Siah Armajani

American, born Iran, 1939

Siah Armajani's public art encourages connection and communication in a divisive world. His bridges span literal and symbolic impasses in order to bring people together. His reading rooms and gardens serve as sites for learning and conversation. His poetry gardens and bandstands provide focal points for community gatherings. Like the 19th-century American philosopher Ralph Waldo Emerson, Armajani believes that art participates in the ethics of daily life.

Elements #16 (Plate 4), with its metaphor of the table as bridge, explores many issues addressed in Armajani's *Irene Hixon Whitney Bridge* (Fig. 48, page 24), built the same year. Spanning 16 lanes of traffic, the pedestrian bridge reunites the Walker Art Center and Minneapolis Sculpture Garden with Loring Park and downtown Minneapolis. *Limit Bridge III* (Plate 5), on the other hand, offers a poignant reminder of the barriers that can block passage and communication.

Chair (Plate 3) is a companion element to Armajani's *Sacco and Vanzetti Reading Room #3*, an installation of rooms, tables, and chairs at the Museum of Modern Art in Frankfurt, Germany. The piece makes reference to Nicola Sacco and Bartolomeo Vanzetti, two immigrant anarchists executed for murder in a controversial case that put America's judicial/political system on trial before the eyes of the world. It identifies reading and thinking as radical and necessary activities in any democracy. *JS*

Plate 4
Siah Armajani
American, born Iran, 1939
Elements #16, 1985–88
steel, aluminum, wood and paint
68 1/2 x 139 1/4 x 40 in. (174 x 353.7 x 101.6 cm)
Gift of the artist in honor of Martin and
Mickey Friedman
F98-25/1 a-d

Plate 5
Siah Armajani
American, born Iran, 1939
Limit Bridge III, 1973–1978
balsa wood
20 x 72 1/2 x 15 in. (50.8 x 184.2 x 38.1 cm)
Gift of Dick and Jane Hollander
F98-26

Constantin Brancusi
French, born Romania, 1876–1957

Constantin Brancusi rose from peasant beginnings in Eastern Europe to become one of the most important sculptors of the 20th century. He studied art in Bucharest and Paris and worked briefly as Auguste Rodin's studio assistant. By 1910 Brancusi had arrived at the pure, reductive style that became his hallmark, a style influenced by the folk art of his native country and by the sculpture of both Africa and ancient Greece.

Brancusi's *Portrait of Nancy Cunard* captures the salient features of the wealthy, Anglo-American writer, publisher and activist he had met in Paris in 1923. Cunard's slender figure, prominent forehead, and receding chin are there, as are her temple curls, transposed as the chignon atop her head. Through nuance and simplification of form, Brancusi's portrait of Cunard conveys a spirit and elegance that would not have been possible in a literal translation of her features. *JS*

Plate 6
Portrait of Nancy Cunard (also called *Sophisticated Young Lady*),
1925–1927
walnut on marble base
24 3/4 x 12 1/2 x 4 3/8 in. (62.9 x 31.8 x 11.1 cm)
The Patsy and Raymond Nasher Collection
at The Nelson-Atkins Museum of Art,
lent by the Hall Family Foundation
37-1991/2

Alexander Calder
American, 1898–1976

Alexander Calder's delicately balanced hanging mobiles and bold, earth-bound stabiles have earned him international respect and affection. Trained as an engineer, Calder caught the attention of European avant-garde artists during the 1930s with his whimsical, small-scale circus constructions complete with moving acrobats made of wire, pulleys and springs.

Calder's acquaintance with Surrealist artists in Paris led him to embark upon a series of abstract sculptures that he called "four-dimensional drawings" because they configured themselves in space-time. Dada artist Marcel Duchamp named Calder's moving sculptures "mobiles," which prompted fellow artist Hans Arp to call the static pieces "stabiles." *Untitled*, a mobile, consists of two found pieces of stained driftwood that reach upward like arms to support a fragile, calligraphic airborne dance of disks. The "Tom" in *Tom's Cubicle* (Plate 8) refers to Tom Messer, director of New York's Guggenheim Museum when the piece was first exhibited there in 1967. *JS*

Plate 7
Untitled, 1937
painted metal and wood standing mobile
61 x 36 x 16 in. (154.9 x 91.4 x 40.6 cm)
The Hall Family Foundation Collection at The Nelson-Atkins Museum of Art
50-1992/2

Plate 8
Alexander Calder
American, 1898 – 1976
Tom's Cubicle, 1967
steel plate
120 x 144 x 84 in. (304.8 x 365.8 x 213.4 cm)
Gift of the Friends of Art
F69-7

John Chamberlain
American, b. 1927

John Chamberlain was one of the first artists to successfully translate the sensibilities of Abstract Expressionist painting into three-dimensional sculptural form. In a manner similar to the "action painting" of Willem de Kooning, Chamberlain creates a gestural energy through curved planes, intersecting angles and the incorporation of contrasting colors. In an almost painterly fashion Chamberlain arranges, bends, crushes and then welds together discarded and wrecked automobile parts, transforming the rawness of such "found" materials into compositions of fluidity and grace. Chamberlain's abstract constructions of urban civilization's cast-offs eventually inspired an approach to Assemblage called "junk art."

Although Chamberlain eventually created free-standing sculptures of massive scale, he began with wall reliefs such as *Huzzy*. Chamberlain's work and use of materials are sometimes construed as social commentary on a society geared toward consumerism and planned obsolescence. This analysis is rejected by the artist, who says that car parts are simply an available material, just as marble was in Michelangelo's time. Instead, Chamberlain's self-professed interest lies in the formal and aesthetic values that can be expressed though abstract arrangements of shape and color. *LF*

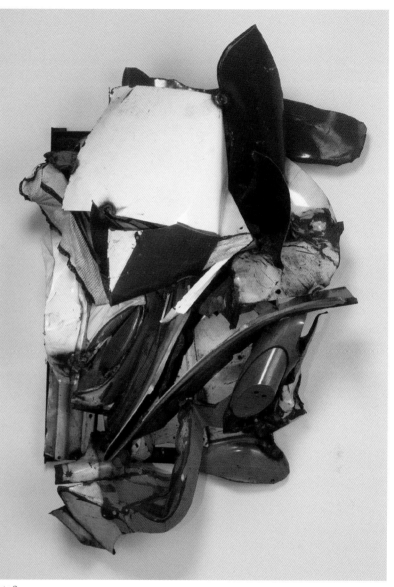

Plate 9
Huzzy, 1961
painted and chromium-plated steel with fabric
54 x 33 x 21 in. (137.2 x 83.8 x 53.3 cm)
Gift of Mrs. Charles F. Buckwalter in memory of Charles F. Buckwalter
F64-8

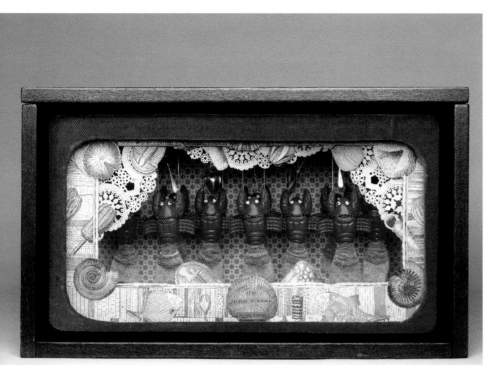

Plate 10
A Pantry Ballet (for Jacques Offenbach), 1942
mixed media
10 1/2 x 18 1/8 x 6 in. (26.7 x 46.1 x 15.2 cm)
Gift of the Friends of Art
F77-34

Joseph Cornell
American, 1903–1972

During the 1930s, Joseph Cornell began arranging found objects in wood and glass boxes he built in the basement of his New York home. Within these miniature worlds, the ordinary becomes the extraordinary and the interconnectedness of things past and present is affirmed.

Pantry Ballet is a three-tiered tribute to dance that celebrates the artist's passion for ballet. Cornell's admiration for 19th-century French composer Jacques Offenbach's operetta *Orpheus in the Underworld*, with its cancan scene, is also clear. The dancing lobsters are inspired by an episode in Lewis Carroll's *Alice in Wonderland* in which Mock Turtle tells Alice that a "Lobster-Quadrille" must be performed in two lines along the seashore. Cornell, who received no formal training in the arts, invests his assemblages with both profound and whimsical references to art, science, and history. *JS*

Jim Dine
American, b. 1935

The Crommelynck Gate with Tools was inspired by the gate leading to the Paris studio of master printmaker Aldo Crommelynck. Dine, who began working with Crommelynck on the production of his own prints in 1973, passed through the wrought iron gate each morning and evening and could observe it from his work table throughout the day.

Rather than replicating the arabesque flourishes of Crommelynck's gate, Dine transformed it into a monumental homage to his friend and to his own passage from 1960s Pop artist to 1980s exponent of Expressionism. The hammers, wrenches, C-clamps, pliers, and axes that embellish this gate reflect Dine's childhood experience in the family hardware store. Tools and other everyday objects have been part of his visual vocabulary since the 1960s. Dine took direct wax castings of the tools, twisted them slightly out of shape, cast them in bronze, and welded them to the cast bronze gate. *JS*

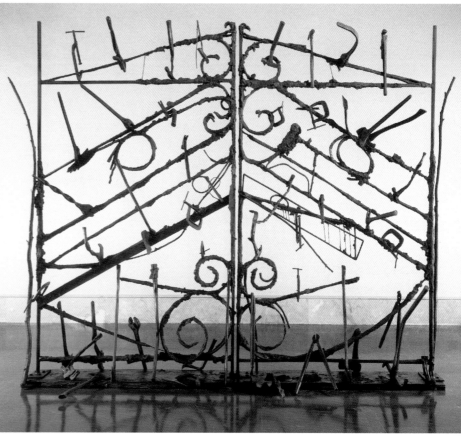

Plate 11
The Crommelynck Gate with Tools, 1984
cast and welded bronze in two parts
108 x 132 x 36 in. (274.3 x 335.2 x 91.6 cm)
Gift of the Friends of Art
F84-76

43

Mark di Suvero
American, b. 1933

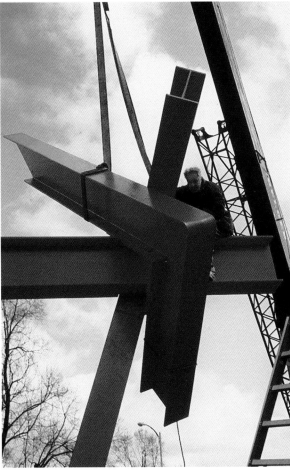

Installation of Rumi *on March 19, 1996, with Mark di Suvero*

Mark di Suvero began making sculptural constructions in the 1950s, incorporating found objects such as giant tires, pieces of machinery and rusted ship prows. His current work frequently features massive steel beams and heavy sheets of metal.

Di Suvero's sculpture celebrates heavy industry. His preference for steel suggests girders used for skyscrapers and bridges; indeed, the orange color of *Rumi* recalls structures such as the Golden Gate Bridge.

Di Suvero's art is often appreciated for its formal qualities — for example, the interaction of his muscular forms with three-dimensional space. In this regard, his work pays homage to the pioneers of construction-based sculpture: Pablo Picasso, Julio Gonzalez, Alexander Calder and David Smith.

According to the late Richard Bellamy, di Suvero's friend and dealer, the twist in *Rumi* may have suggested dance movements, inspiring the artist to name the sculpture after Jalal al-Din Rumi, a 12th-century Persian poet and spiritual leader. Rumi's writings inspired his followers to create an Islamic religious order, often called the "Whirling Dervishes," who express their beliefs through energetic, twirling dance rituals. Moreover, when viewing *Rumi in situ*, the torquing sculpture compels visitors to walk around it in a circle, somewhat recalling the dance of the "Whirling Dervishes." *JM*

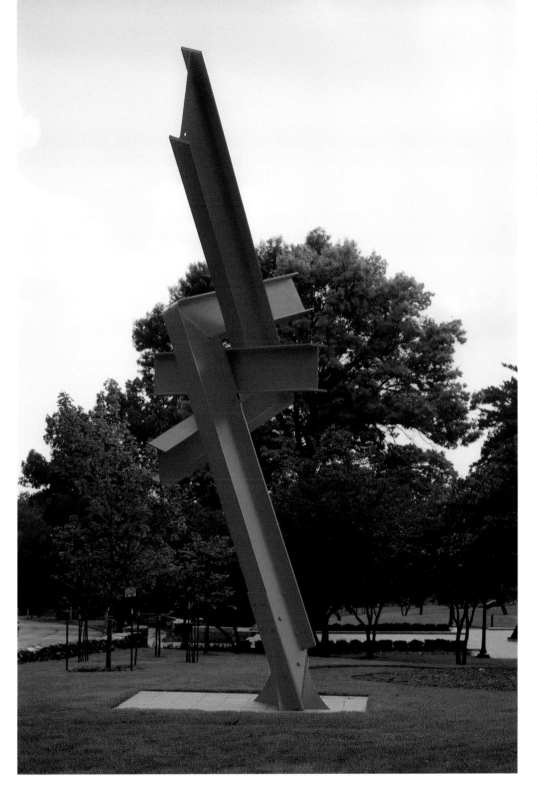

Plate 12
Mark di Suvero
American, b. 1933
Rumi, 1991
painted steel
24 ft. high (731.5 cm)
The Hall Family Foundation Collection at
The Nelson-Atkins Museum of Art
1-1996

Max Ernst
French, born Germany, 1891–1976

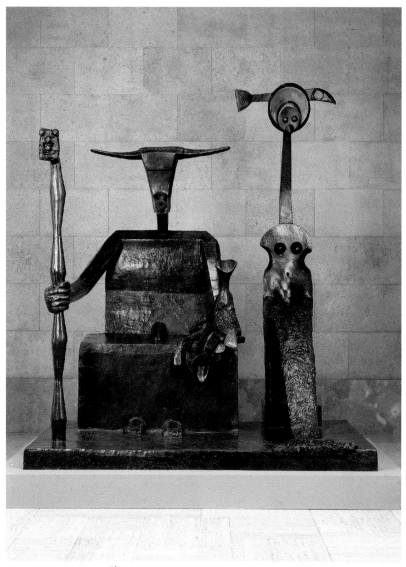

Plate 13
Capricorn, 1948; cast 1963–1964
bronze
95 1/2 x 82 x 55 1/4 in. (242.6 x 208.3 x 140.3 cm)
The Patsy and Raymond Nasher Collection at
The Nelson-Atkins Museum of Art, lent by the Hall Family Foundation
37-1991/3

Capricorn is often considered the culmination of Max Ernst's body of work. It addresses issues of myth and identity first raised in works like *Oedipus Rex* from 1922 and later explored in great depth during his affiliation with Surrealism from 1924 to 1938. It is a slightly modified version of the original concrete sculpture that symbolically guarded Ernst's home in Sedona, Arizona, from 1948 to 1953.

Capricorn is first a portrait of Ernst and his artist wife, Dorothea Tanning. On another level, the male and female figures represent archetypal notions of duality. Ernst invested *Capricorn* with the taut frontality of ancient Egyptian royal portraiture and paid homage to the horned figures of both Cycladic Greece and the Nordic world. *Capricorn* also makes reference to Kwakiutl totem poles, minotaur and mermaid myths, the game of chess, and the lusty, horned goat of astrology, which is the traditional birth sign for light-bringing gods and kings, from Zeus to Augustus to Jesus. *JS*

46

Dan Flavin
American, b. 1933

Dan Flavin began his career in the late 1950s by drawing and painting in an Abstract Expressionist mode and building constructions with collages and found objects. In 1961 he began to include electric lights in his constructions and eventually focused on light as a medium.

Flavin's work is characterized by fluorescent light bulbs of various colors that are sometimes grouped together. Other times they are exhibited alone, propped in a corner or hung on a wall diagonally.

Flavin prefers simple, unadorned fluorescent fixtures, which he appreciated for their "raw hardware" appearance. When lighted, these sculptures transform the room surrounding them into part of the overall work. The fixtures themselves become nearly invisible, creating a tension between the hardness of the artist's raw materials and the aura of light that is produced. Flavin's reduction of his materials to light itself and his investigation of physical objects and spaces align him with the concerns of Minimalists such as Donald Judd.

Flavin's sculptures are often dedicated to friends and associates in the art world, as in *Untitled (to the real Dan Hill)* and *Untitled (to Annalee fondly)* (Plate 15), which alludes to the wife of painter Barnett Newman. *JM*

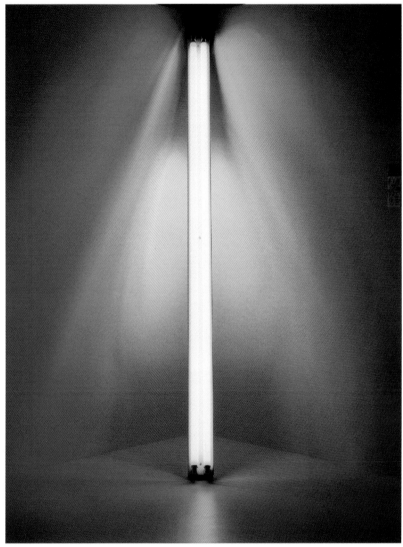

Plate 14
Untitled (to the real Dan Hill), 1978
blue, green, yellow and pink fluorescent light
96 x 5 1/4 x 9 in. (243.8 x 13.3 x 22.9 cm)
Gift of The Guild of the Friends of Art
F85-26

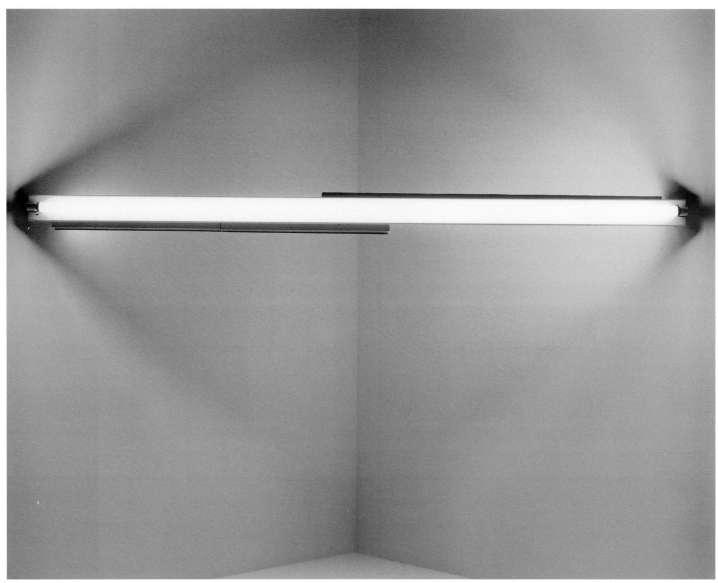

Plate 15
Dan Flavin
American, b. 1933
Untitled (to Annalee fondly), 1971
pink, yellow, and green fluorescent light on metal fixtures
6 x 96 x 7 3/4 in. (15.2 x 243.8 x 19.7 cm)
Gift of Virginia Dwan
F95-13 a-f

Alberto Giacometti
Swiss, 1901–1966

Alberto Giacometti joined the Paris-based Surrealist group in 1930 and for the next five years explored themes of myth, sexuality, and violence in his work. He abandoned Surrealism in 1935, returning to more naturalistic investigations of the human figure.

Over a 10-year period, during which the world experienced its second great war, Giacometti struggled to match his inner understanding of the human being with what his eyes told him to be true. Giacometti's work bears striking affinities with the philosophy of his friend Jean-Paul Sartre, whose Existentialism emphasized the isolation of the individual in an indifferent universe where one's existence is defined by each choice one makes. The female figure in *The Chariot*, with its emaciated form, anguished surface, solitary presence and precarious stance, is a stark and powerful reminder of the fragility of life. *JS*

Plate 16
The Chariot, 1950
painted bronze
56 1/4 x 24 1/4 x 27 in. (142.9 x 61.6 x 68.6 cm)
The Patsy and Raymond Nasher Collection
at The Nelson-Atkins Museum of Art,
lent by the Hall Family Foundation
37-1991/4

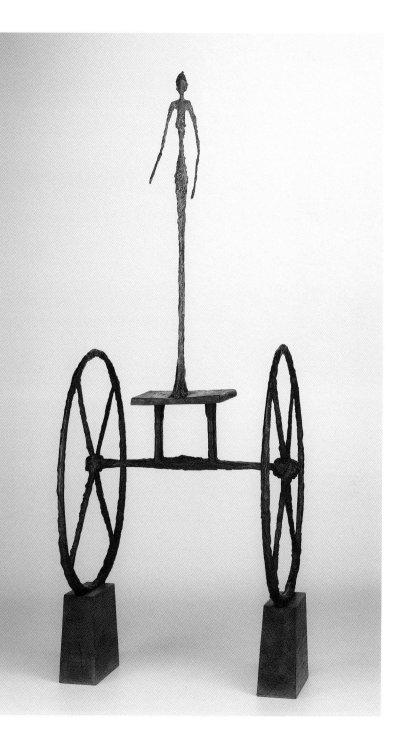

Plate 17
Zaga, 1983
cast bronze with polychrome chemical patination
72 x 49 x 32 in. (182.9 x 124.5 x 81.3 cm)
Gift of the Friends of Art
F84-27

Nancy Graves
American, 1940–1995

Beginning in the 1960s, when she constructed camels of polyurethane, burlap and animal skins, Nancy Graves challenged the boundaries of accepted materials, techniques and subject matter in sculpture. Graves grew up in Pittsfield, Massachusetts, where her father was assistant director of the Berkshire Museum. Her early encounters with the museum's displays of art and natural history led her to create works influenced by paleontology, archaeology and anthropology.

Graves' unusual bronze technique allows her to capture the world surrounding her and reveal its details, much like the scientists whom she observed working at the Berkshire Museum. Unlike many artists that work in bronze, Graves used a direct casting technique, rather than *cire perdue*, or the lost wax method. In *Zaga*, objects such as the leaves of the monstrosa, hupa fern and Chinese cooking scissors were directly cast into bronze, retaining their original identities and serving as their own armatures. The individual bronze objects were then welded together and given a patina of bold colors that actually are fused to the metal. *Zaga* was titled in homage to a group of sculptures by David Smith (1906–1965), called *Zig*s. Like Smith's works, the form of *Zaga* strikes a delicate balance that seems to defy gravity and the weight of the bronze metal. *LF*

Duane Hanson
American, 1925–1996

Duane Hanson's sculptures depict the face of contemporary America with startling realism. Although he depicts American types in works like *The Shoppers*, *Tourists*, and *Woman Derelict*, these types are also individuals. Their solitary demeanor, weary expressions, clothing and accoutrements are familiar and specific.

Museum Guard wears a badge like those worn by security officers at The Nelson-Atkins Museum of Art. Like them, he stands watchfully in the gallery. This sculpture began with the application of plastered bandages to a live model. The dry-mold sections were removed from the model's body, greased on the interior, and filled or coated with liquid polyvinyl acetate. When hardened, the casts were removed from their molds, assembled, and sealed with shellac. Hanson then painted the figure, adding hair and clothing to complete the illusion. *JS*

Plate 18
Museum Guard, 1975
polyester, fiberglass, oil, and vinyl
69 x 31 x 13 in. (175.3 x 78.7 x 33 cm)
Gift of the Friends of Art
F76-40

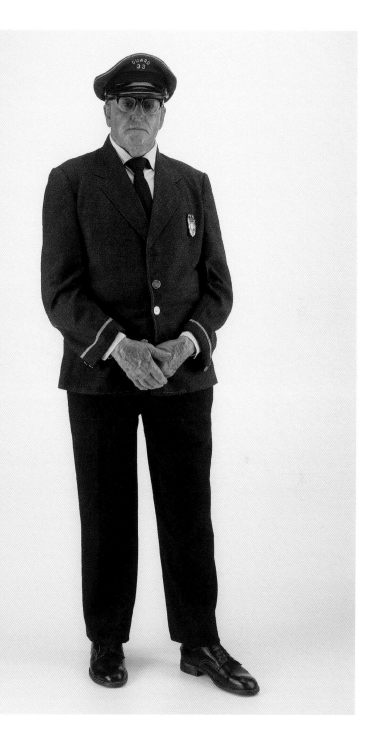

Magdalena Jetelova
Czechoslovakian, b. 1946

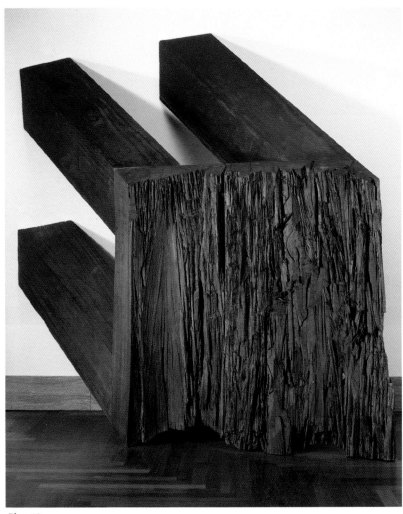

Magdalena Jetelova has gained international recognition since she fled the artistic restrictions of her native Czechoslovakia and immigrated to West Germany in 1985. Jetelova works with wood, the material she feels is most capable of expressing nature's powerful forces. Her subjects are familiar: domestic objects such as chairs, stairways, and tables. Jetelova transforms these simple objects — symbols of the human need for organization, shelter, and security — into powerful metaphors for what she calls "the absurdities of life."

In *Tisch*, Jetelova has dramatically expanded the scale of a typical table and aggressively gouged and splintered its surface with axes and chisels. These qualities, combined with the surprising thrust of the table's massive weight from wall to floor, suggest the intervention of a violent, superhuman force. The artist's intentional, radical shift of gravitational energy, which creates a sense of precarious balance, provides a metaphor for the unstable relationship between humans and nature. *LF*

Donald Judd
American, 1928–1994

Donald Judd is internationally recognized as one of the most important innovators of minimal or reductive art. Minimalism originated as a reaction, in part, to the highly personal and intuitive spontaneity of Abstract Expressionism. Minimalist sculpture is characterized by its reduced number and variety of forms and by its elimination of expressive, artistic emotion.

Large Stack is made up of units whose rational, geometric simplicity and systematic spatial relationships make them indistinguishable from each other. Judd uses industrial materials — in this case prefabricated stainless steel and Plexiglas sheets — as a conscious rejection of craftsmanship.

Judd deliberately attempted to demystify the work of art as a unique, precious object. As a result, there are 32 versions of his "stacks," which are always fabricated by others. *JS*

Plate 20
Large Stack, 1968
stainless steel and amber Plexiglas
185 x 40 x 31 in.
(469.9 x 101.6 x 78.7 cm)
Gift of the Friends of Art
F76-41

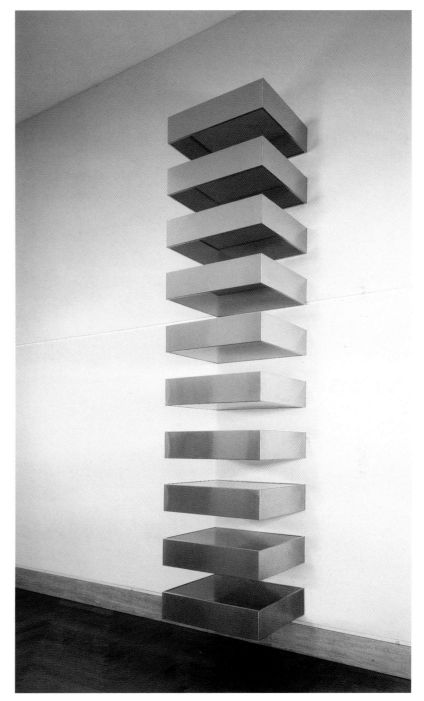

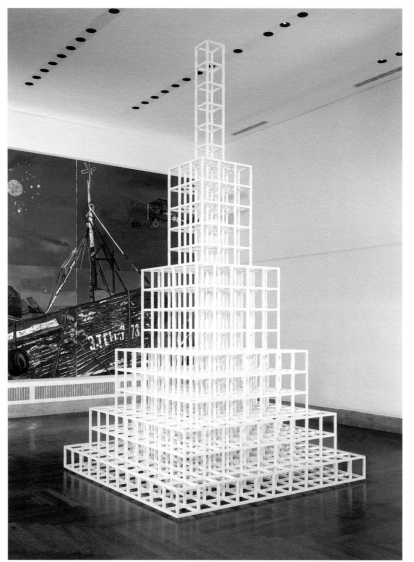

Plate 21
1 3 5 7 9 11,
conceived 1994; fabricated 1996
baked enamel on aluminum
16 ft.6 in. x 8 ft. 8 in. x 8 ft. 8in.
(5 x 2.6 x 2.6 m)
The Hall Family Foundation Collection at
The Nelson-Atkins Museum of Art
2-1996

Sol LeWitt
American, b. 1928

Sol LeWitt first came to art-world prominence in the 1960s as one of the pioneers of Conceptual art, which considers the idea behind an art work more important than the object itself. LeWitt's gridlike works are also frequently associated with the geometric forms of Minimalists such as Carl Andre and Donald Judd.

1 3 5 7 9 11 was commissioned for the Museum's Parker-Grant gallery. Like many of LeWitt's structures, it existed first as a drawing, then as a wooden model. The A. Zahner Company of Kansas City fabricated the full-scale work.

The concept of each LeWitt sculpture is evident in its appearance. For example, *1 3 5 7 9 11* is based on the measurement unit of one cube. The sculpture's top section is one cube wide; the next section is three cubes wide, followed by a section five cubes wide and so on. The height of each section follows a related logic; the bottom section is one cube high, followed above by sections that are two, three, four, five and six cubes high.

ABCD 2 (Row) (Plate 22) features one form within another and all its major variations. From left to right is an open cube on an open grid; a closed cube on an open grid; an open cube on a closed grid; and a closed cube on a closed grid. *JM*

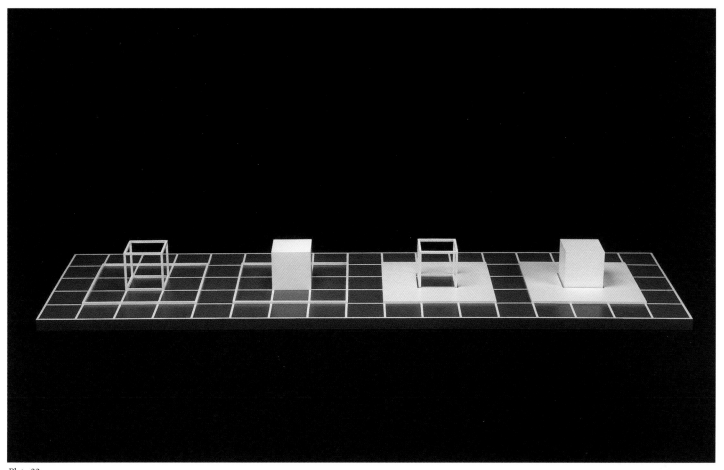

Plate 22
Sol LeWitt
American, b. 1928
ABCD 2 (Row), 1992
baked enamel on steel
8 5/8 x 31 3/4 x 107 1/2 in. (21.9 x 80.6 x 273.1 cm)
Gift of Virginia Dwan
F96-15 a-i

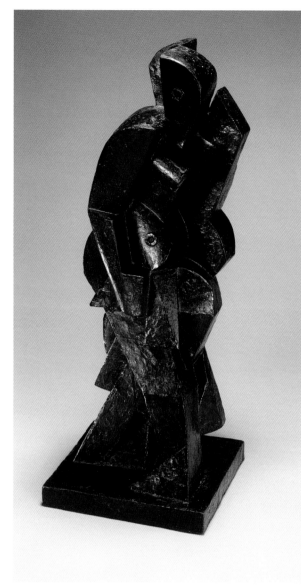

Jacques Lipchitz
American, born Lithuania, 1891–1973

When Lithuanian-born sculptor Jacques Lipchitz immigrated to Paris in 1909, his friendship with Juan Gris and Pablo Picasso led him to explore Cubism in his sculptures. In *Bather* (Plate 23), a Cubist work, the analysis of geometric form is more important than psychological or spiritual content. By the late 1920s, Lipchitz was moving away from Cubism toward a looser style based on natural forms, and he began to explore human themes and ideas in his art, rather than pure forms.

Although more fluid than his early Cubist work, *Return of the Prodigal Son* (Plate 25) retains a disciplined angularity. In Lipchitz's first interpretation of a biblical theme, the figure of the son arches over the mother in a passionate embrace that is expressive of departure, return and reconciliation.

In *Theseus* (Plate 24), the legendary Greek hero and king of Athens slays the monstrous Minotaur. Made during World War II, this fully expressionistic work suggests the struggle of good and evil and the hope for the triumph of democracy over fascism. Theseus and the Minotaur can be interpreted as two aspects of the same being; as such, it is a representation of man at war with the forces of his own nature.

A masterwork dating to 1969, the monumental *Peace on Earth* (Plate 26) incorporates motifs and themes Lipchitz began exploring more than 20 years earlier. The tangled masses at the base represent *prima materia*, or the raw flesh of the earth. Progressing upward, we see the Lamb of God, angels, the Virgin Mary and ultimately the Holy Spirit in the traditional form of a dove. *Peace on Earth* is an optimistic work expressive of the transformation of flesh into spirit; its broader, underlying theme of metamorphosis resurfaced throughout Lipchitz's career. *LF*

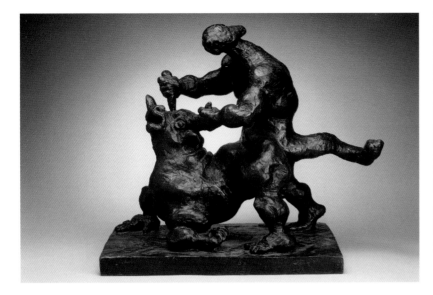

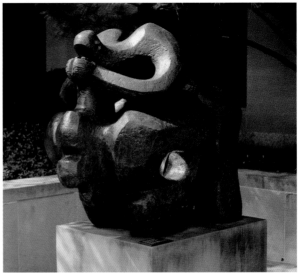

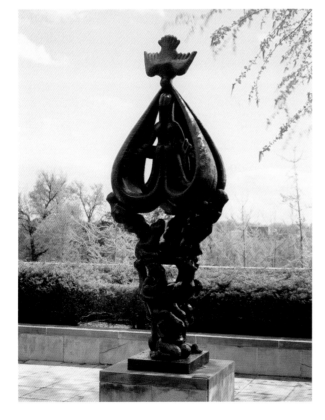

Plate 24 (above, left)
Jacques Lipchitz
American, born Lithuania, 1891–1973
Theseus, 1942
bronze
24 1/2 x 28 1/2 x 14 1/2 in. (62.2 x 72.3 x 36.8 cm)
Gift of the Friends of Art
57-98

Plate 25 (above, right)
Jacques Lipchitz
American, born Lithuania, 1891–1973
Return of the Prodigal Son, 1931
bronze
42 x 37 x 44 in. (106.7 x 94.0 x 11.8 cm)
Gift of Mrs. R.C. Kemper Sr., through the R.C. Kemper Charitable Trust
F74-32

Plate 26 (left)
Jacques Lipchitz
American, born Lithuania, 1891–1973
Peace on Earth, 1969
bronze, one of seven castings
131 x 51 x 42 in. (332.7 x 129.6 x 106.7 cm)
Purchase: the Elmer F. Pierson Foundation
F72-20

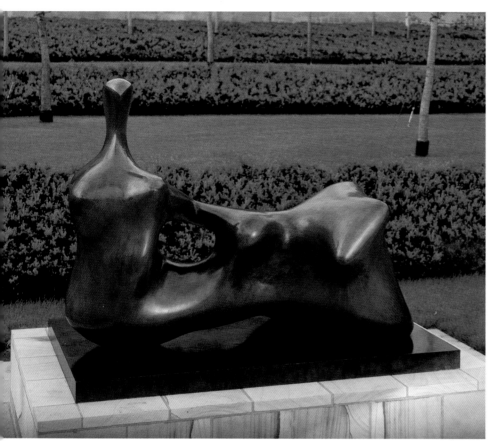

Plate 27
Reclining Figure: Hand, 1979
bronze
65 x 88 x 52 in. (165.1 x 223.5 x 132 cm)
The Hall Family Foundation Collection
at The Nelson-Atkins Museum of Art
66-1986/3

Henry Moore
British, 1898–1986

British sculptor Henry Moore revered nature as a living, generative force and saw the female figure as its primary embodiment. His organically abstracted versions of ancient fertility goddesses appear reclining, sitting, and standing. They are presented alone, with child, and in family groups. The swells and cavities of their bodies echo those of the landscape while their solid masses evoke the enduring strength of rock. Their bellies, arms, and breasts enfold and nurture. The sources for Moore's figurative and non-figurative works can be found in Egyptian, Greek, and Pre-Columbian sculpture as well as in rocks, bones, trees and other natural phenomena.

The Nelson-Atkins Museum of Art and The Kansas City Sculpture Park are home to the largest collection of Henry Moore's monumental bronze sculptures outside his native Great Britain. These 14 monumental sculptures, together with nearly 50 maquettes and working models, tapestries, drawings and prints, provide a rare opportunity to study the work of one of this century's most prolific and respected sculptors. *JS*

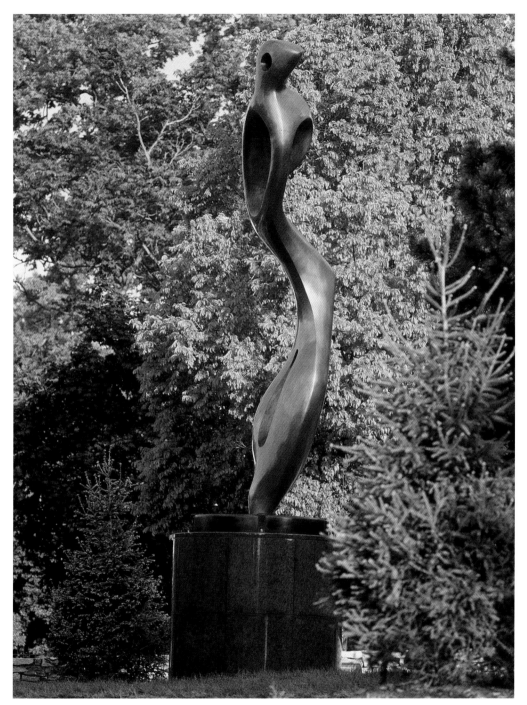

Plate 28
Henry Moore
British, 1898–1986
Large Interior Form, 1953, cast 1981
bronze
16 feet, 3 inches high (5 m high)
The Hall Family Foundation Collection at
The Nelson-Atkins Museum of Art
66-1986/4

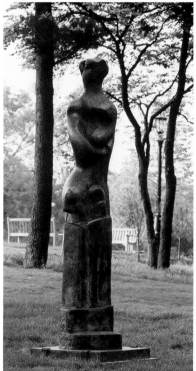

Plate 29
Henry Moore
British, 1898–1986
Upright Motive No. 9, 1979
bronze, ed. of 6
144 x 41 1/2 x 41 1/2 in.
(365.8 x 105.4 x 105.4 cm)
The Hall Family Foundation Collection at
The Nelson-Atkins Museum of Art
66-1986/6

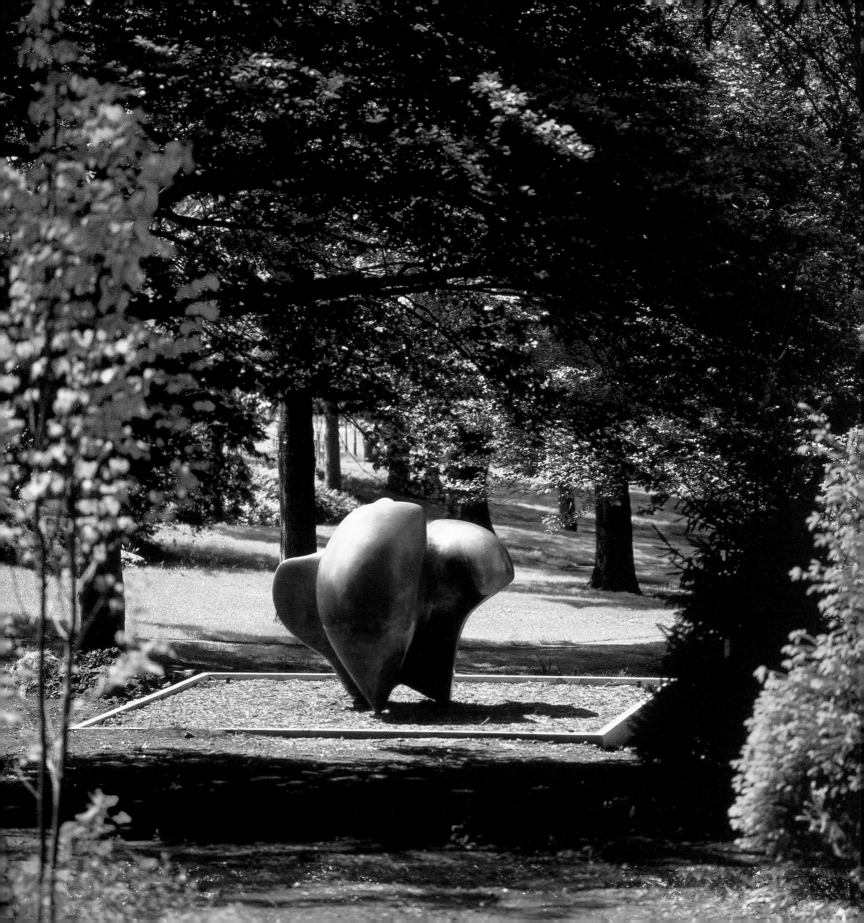

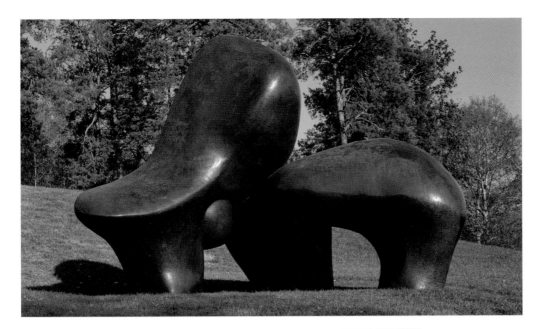

Plate 30 (facing page)
Henry Moore
British, 1898–1986
Three Way Piece No. 1: Points, 1965–1966
bronze
78 x 82 x 93 in. (198.1 x 208.3 x 236.2 cm)
The Hall Family Foundation Collection at
The Nelson-Atkins Museum of Art
2-1987/1

Plate 31 (left)
Henry Moore
British, 1898–1986
Sheep Piece, 1971–1972
bronze
14 feet high (4.3 m high)
Board of Parks and Recreation
Commissioners, Gift of N. Clyde Degginger

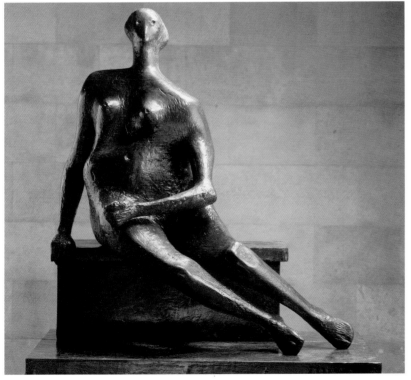

Plate 32
Henry Moore
British, 1898–1986
Seated Woman, 1957
bronze, ed. of 6
61 x 57 1/2 x 41 3/4 in. (154.7 x 146 x 106 cm)
The Hall Family Foundation Collection at
The Nelson-Atkins Museum of Art
66-1986/1

Elie Nadelman
American, born Poland, 1882–1946

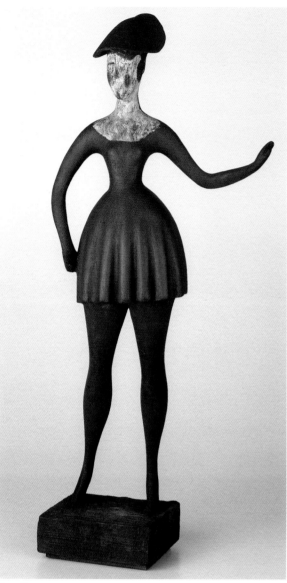

Now recognized as one of the pioneers of modern art, Elie Nadelman worked in Paris between 1904 and 1914, where he helped revolutionize modern sculpture. One of his most important innovations was to simplify the human figure by breaking it down into basic geometric forms such as cylinders, ovals, and planes. In 1990, Nadelman's declaration that "The subject of any work of art for me is nothing but a pretext for creating significant form…" sheds light on his role as a modern pioneer.

Standing Girl shows this idea at work. The girl's angled beret forms an imaginary plane that directs our eyes to her right arm and leg. Nadelman balanced this strong directional plane with a large open space beneath her left arm on the other side of the sculpture. In a similar way, the beret helps balance the girl's bell-shaped skirt.

Despite Nadelman's statement above, this work does have a relationship to life outside of art. The beret and short skirt identify this girl as a modern, sophisticated woman of 1920. Because of her playful appearance, *Standing Girl* may be a satire of the privileged high society figures that the artist knew in New York.

Standing Girl belongs to a series Nadelman carved from wood, a material that he explored a great deal after immigrating to New York in 1914. His interest in uncomplicated wood sculpture may have been influenced by the American folk art that he collected. *LF*

Plate 33
Standing Girl, 1918–1920
cherry wood, gesso, and paint
30 3/4 x 12 1/4 x 5 3/4 in. (78.1 x 31.1 x 14.6 cm)
Gift of Julia and Humbert Tinsman
F91-62

Louise Nevelson
American, born Russia, 1900–1988

A self-proclaimed "architect of shadows," Louise Nevelson salvaged packing crates, printer's boxes, pieces of broken furniture, discarded architectural ornaments and scrap lumber from the streets, factories and loading docks of New York City. Assembled and unified by a single color, the original functions of these parts are subsumed within the new meaning of the whole. Although she occasionally used white and gold paint, black was Nevelson's color of choice. "Black is harmony," she wrote. "Black means totality."

In her gardens, landscapes, columns, houses, wall reliefs and room environments, Nevelson recreated what she called "the in-between places." *End of Day, Nightscape IV* (Plate 35) and *Dream House XXXIX* evoke the dawns and dusks, the spaces between land and sea, the world between objectivity and spirit. It is to these places that she takes those who would go with her. *JS*

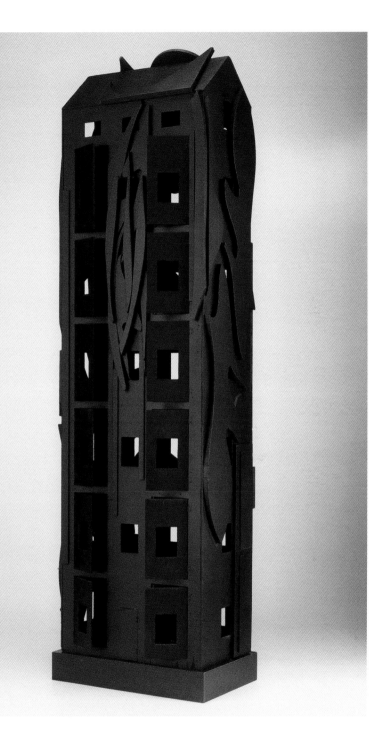

Plate 34
Dream House XXXIX, 1973
paint on wood
86 1/4 x 25 3/4 x 16 1/2 in.
(241.3 x 424.2 x 17.7 cm)
Gift of the American Art Foundation
F96-23/1

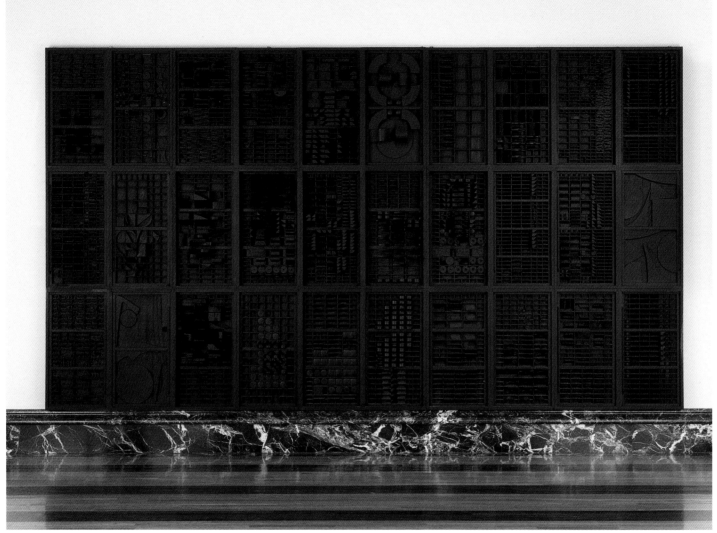

Plate 35
Louise Nevelson
American, born Russia, 1900–1988
End of Day, Nightscape IV, 1973
painted wood
95 x 167 x 7 in. (241.3 x 424.2 x 17.7 cm)
Gift of the Friends of Art
F74-30

Isamu Noguchi
American, 1904–1988

Isamu Noguchi was one of the most innovative American artists of the 20th century, creating extraordinary sculptures; landscape and urban designs; stage environments and lighting; furniture; and interiors. Noguchi was born in Los Angeles of a Japanese father and an American mother, but he was raised in Japan. He returned to the United States as a teen and studied art in college. As an adult, Noguchi traveled extensively and split his time between studios in New York and Japan.

Noguchi embraced his Japanese heritage, yet considered himself a citizen of the world. Accordingly, his art synthesizes concepts of beauty found in Japanese art, modern European and American art, and ancient traditions from all over the world. For example, *Fountain* (Plate 41) recalls *tsukubai*, small washbasins found in Japanese gardens that are used in the tea ceremony. The title of *Avatar* refers to the earthly descent of a Hindu deity, while its organlike appendages recall Noguchi's interest in Surrealism, the European literary and artistic movement that often referred to the human body. Finally, moundlike forms on *Mountain Landscape* (Plate 39) and a pyramid shape on *Night Land* (Plate 40) suggest ancient burial monuments in Meso-America and Egypt. *JM*

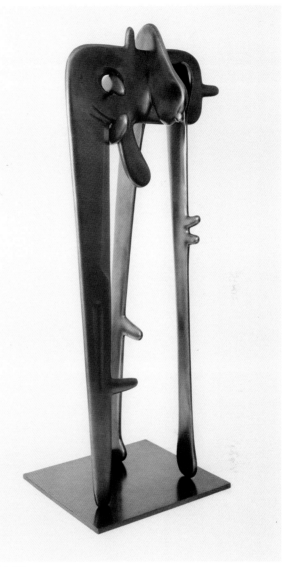

Plate 36
Avatar, 1947, cast 1988
bronze
78 x 33 x 24 in. 78 x 33 x 24 in. (198 x 83.8 x 60.9 cm)
The Hall Family Foundation Collection at
The Nelson-Atkins Museum of Art
30-1998/4

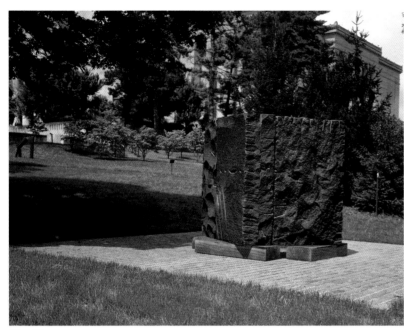

Plate 37
Isamu Noguchi
American, 1904–1988
Ends, 1985
Swedish granite
72 x 72 x 71 1/4 in. (182.9 x 182.9 x 181.0 cm)
The Hall Family Foundation Collection at
The Nelson-Atkins Museum of Art
19-1996

Plate 38
Isamu Noguchi
American, 1904–1988
Endless Coupling, 1988
red Swedish granite
94 1/2 x 23 3/4 x 23 3/4 in. (240.0 x 60.3 x
60.3 cm)
The Hall Family Foundation Collection at
The Nelson-Atkins Museum of Art
30-1998/2

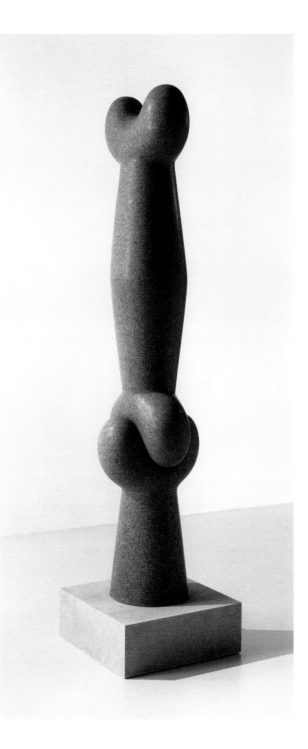

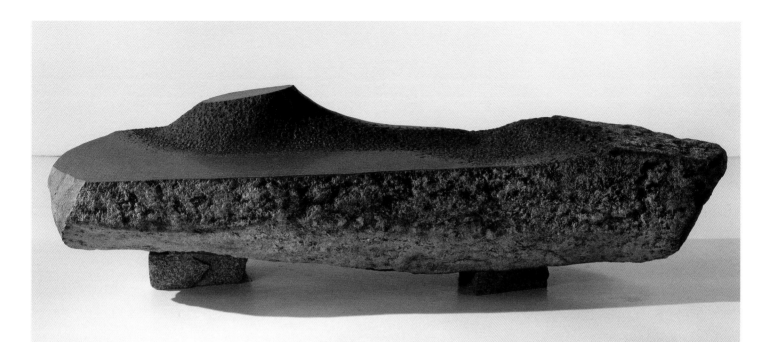

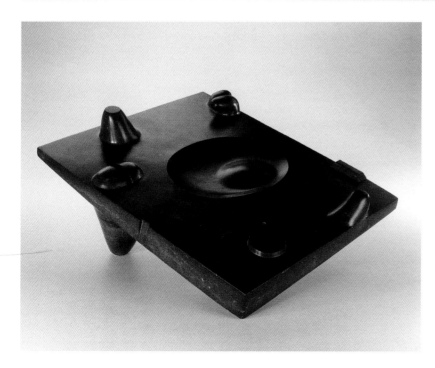

Plate 39 (above)
Isamu Noguchi
American, 1904–1988
Mountain Landscape (Bench), 1981
basalt
25 x 83 1/2 x 28 in. (63.5 x 212.1 x 71.1 cm)
The Hall Family Foundation Collection at
The Nelson-Atkins Museum of Art
30-1998/1

Plate 40 (left)
Isamu Noguchi
American, 1904–1988
Night Land, 1947
York fossil marble
22 x 47 x 37 1/2 in. (55.9 x 119.4 95.3 cm)
The Hall Family Foundation Collection at
The Nelson-Atkins Museum of Art
50-1992/1

Plate 41
Isamu Noguchi
American, 1904–1988
Fountain, 1987
basalt
43 1/4 x 51 x 38 in.
(109.9 x 129.5 x 96.5 cm) and
40 1/2 x 46 x 36 in.
(102.9 x 116.8 x 91.4 cm)
The Hall Family Foundation Collection at
The Nelson-Atkins Museum of Art
30-1998/3

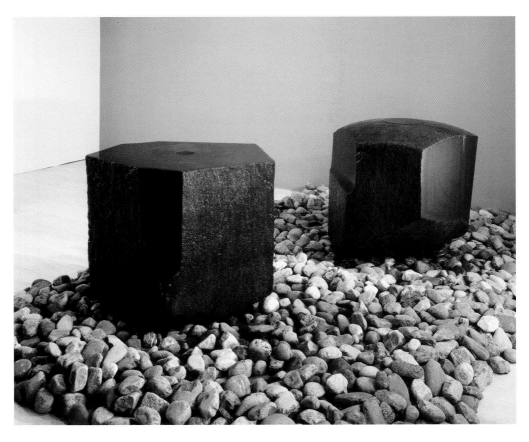

Plate 42
Isamu Noguchi
American, 1904–1988
Six-Foot Energy Void, 1971-1985
Swedish granite
71 1/2 x 61 1/2 x 22 1/2 in.
(181.6 x 156.2 x 57.15 cm)
The Hall Family Foundation Collection at
The Nelson-Atkins Museum of Art
51-1992

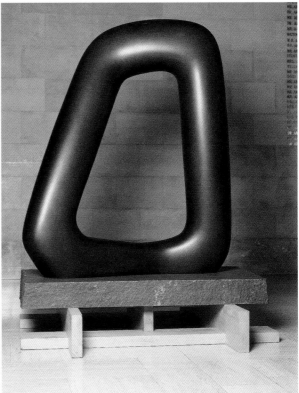

Claes Oldenburg
American, born Sweden, 1929

Claes Oldenburg is one of the best-known artists associated with the Pop Art movement of the 1960s. Pop surfaced in New York City in the late 1950s when artists such as Oldenburg, Andy Warhol and Roy Lichtenstein began to react against the serious and introspective nature of Abstract Expressionist painting. They rejected abstraction and looked to popular culture as a source for their imagery.

Common, everyday objects became the primary sources of inspiration for Oldenburg's work. He created surprising "soft" versions of familiar objects as seen in *Soft Saxophone, Scale B* (Plate 43) and *Switches Sketch* (Plate 46) by radically altering their size, material and texture. In the mid-1960s, Oldenburg began making drawings that translated his versions of ordinary objects into proposals for large-scale public sculptures. *The Nelson-Atkins Museum of Art as a Net, with Shuttlecocks* (Plate 44) is a 1990s continuation of this way of working. The outdoor installation of the monumental *Shuttlecocks* at The Nelson-Atkins Museum of Art is a collaboration between Oldenburg and Coojse van Bruggen, his wife and collaborator. In response to the formality of the Museum's architecture and the green expanse of its surrounding lawn, the artists imagined the Museum as a net and the lawn as a playing field. The artists created four "birdies" and sited them as if a badminton game had just concluded and the shuttlecocks had landed. Each shuttlecock sculpture weighs 5,500 pounds, stands 17 feet, 10 3/4 inches tall, and has a diameter of approximately 16 feet. *LF*

Plate 43
Soft Saxophone, Scale B, 1992
canvas, wood, clothesline, Dacron, resin, and latex paint
97 x 63 x 60 in. (246.4 x 160.0 x 152.4 cm), with base
The Hall Family Foundation Collection at
The Nelson-Atkins Museum of Art
50-1992/4

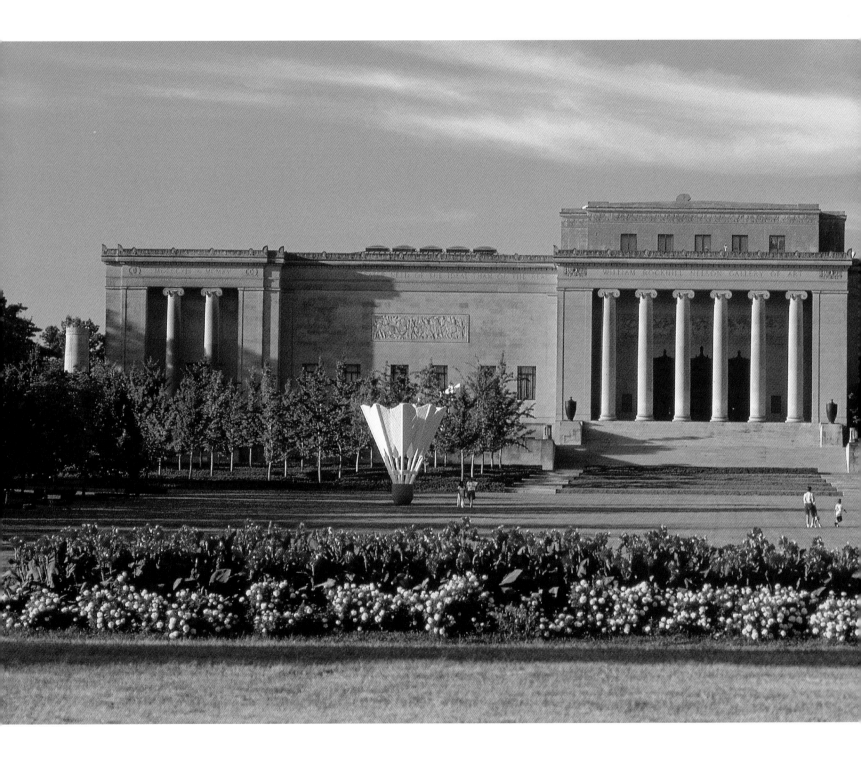

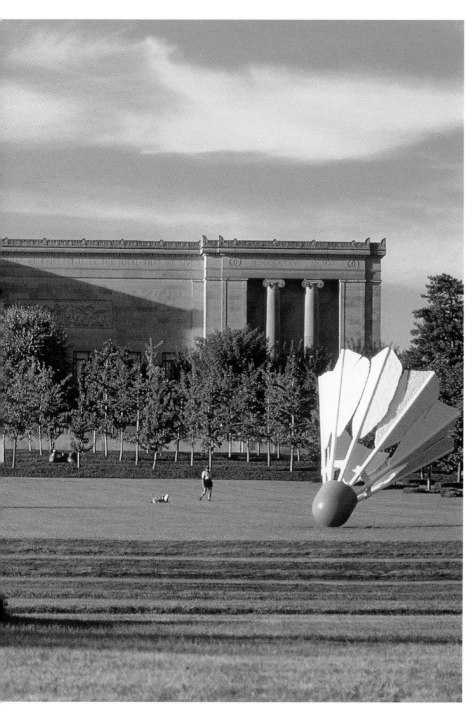

Plate 45 (above)
Claes Oldenburg
American, born Sweden, 1929
The Nelson-Atkins Museum of Art as a Net, with Shuttlecocks, 1992
graphite and pastel on paper
30 1/8 x 40 in. (76.5 x 101.6 cm)
Gift of Claes Oldenburg and Coosje van Bruggen
F94-16

Plate 44 (left)
Claes Oldenburg,
American, born Sweden, 1929
Coosje van Bruggen,
American, born The Netherlands, 1942
Shuttlecocks, 1994
aluminum and fiberglass
4 elements:
19 ft. 2 1/2 in. x 17 ft. 5 in. x 15 ft. 11 3/4 in. (5.9 x 5.3 x 4.9 m)
20 ft. x 15 ft. x 15 ft. 11 3/4 in. (6.1 x 4.6 x 4.9 m)
17 ft. 11 3/4 in. x 17 ft. 5 in. x 15 ft. 11 3/4 in. (5.5 x 5.3 x 4.9 m)
18 ft. 3 1/2 in. x 18 ft. 10 in. x 15 ft. 11 3/4 in. (5.6 x 5.7 x 4.9 m)
Purchase: acquired through the generosity of the Sosland Family
F94-1/1-4

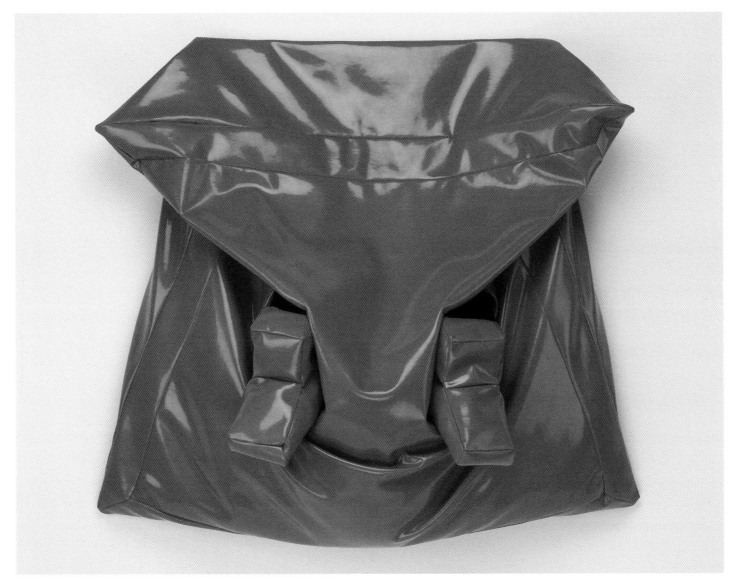

Plate 46
Claes Oldenburg
American, born Sweden, 1929
Switches Sketch, 1964
vinyl and Dacron
47 x 47 x 3 5/8 in. (119.4 x 119.4 x 9.2 cm)
Gift of the Chapin Family in memory of Susan Chapin Buckwalter
65-29

Martin Puryear
American, b. 1941

Martin Puryear has been hailed by critics as one of the best sculptors alive. He has exhibited his work worldwide and has received numerous awards. In 1989, he was awarded best artist at the São Paulo Bienal, a major international exhibition.

Puryear creates evocative, non-representational forms that honor diverse cultural traditions. While working for the Peace Corps in Sierra Leone, he became interested in three-dimensional form and learned carving and joining techniques from the local builders and craftsmen. Puryear also studied at the Swedish Royal Academy in Stockholm, where he was inspired by Scandinavian design and learned traditional wood construction techniques from master cabinetmakers.

Plenty's Boast is an excellent example of Puryear's skill with wood, his favorite material. For example, even though the material is rigid, the round opening of the sculpture appears flexible. Furthermore, by manipulating the direction of the wood grain, Puryear made the telescopic "tail sections" seem to be capable of turning, but in fact they are fixed.

As the title suggests, *Plenty's Boast* refers to a cornucopia, a "horn of plenty," yet the emptiness of the cone lends an ironic dimension to the meaning of "plenty." In addition, the sculpture is sometimes compared to a fantastic sea creature or a sound instrument. *JM*

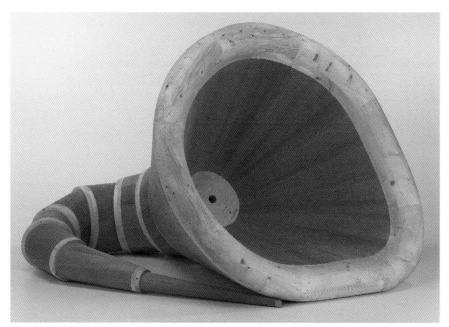

Plate 47
Plenty's Boast, 1994–1995
red cedar and pine
68 x 83 x 118 in. (172.7 x 210.8 x 134.6 cm)
Purchase: the Renee C. Crowell Trust
F95-16 a-c

Auguste Rodin
French, 1840–1917

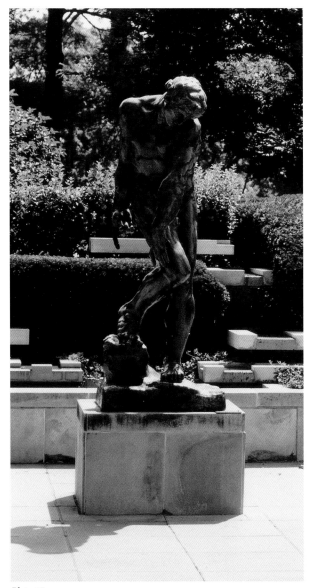

Plate 48
Adam, 1880
bronze
77 x 29 x 29 in. (195.6 x 73.6 x 73.6 cm)
Purchase: Nelson Trust
55-70

In 1880, the French government awarded Rodin the commission for the *Gates of Hell*, a large sculptural portal. The building for which the project was proposed never materialized and Rodin refunded the award, yet continued to work on the massive sculpture for the rest of his life. The enormous portal, cast posthumously, was inspired by scenes from Dante's *Inferno* and consisted of some 200 figures imprisoned within agitated and anguished states. The teeming figures were a vast and melancholy meditation on the tragedy of the human condition and the plight of souls trapped in eternal longing and despair.

Many of the figures created for the *Gates of Hell* are at least equally famous as individual, large-scale sculptures. *The Thinker* (Plate 49) and *Adam* are examples of works that were recreated as separate, monumental works of art. Both sculptures acknowledge Rodin's awareness of Michelangelo, particularly in the muscularity and expressive power of bodily form, as well as in the sense of pent-up energy or action-in-repose, so often associated with Michelangelo.

Unlike Michelangelo, who carved directly in marble, Rodin was first and foremost a modeler, starting with clay and then transforming the clay model into plaster and then bronze. So expressive are Rodin's surfaces that some of his bronze sculptures retain imprints of the artist's fingers, left behind in the original clay model. *LF*

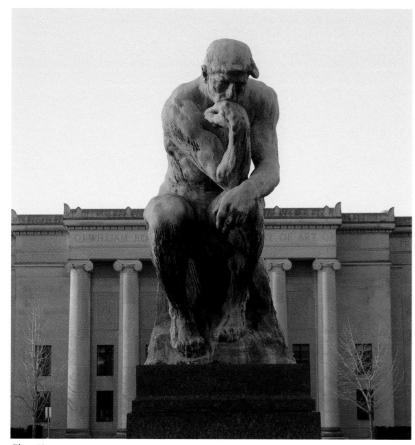

Plate 49
Auguste Rodin
French, 1840–1917
The Thinker, 1880
bronze
73 x 58 x 39 in. (185.4 x 147.3 x 99.1 cm)
Board of Parks and Recreation Commissioners,
Gift of Grant I. and Mathilde Rosenzweig, 1948

Plate 50
Auguste Rodin
French, 1840–1917
Study of a Seated Man, ca. 1874–1875
wax
14 1/2 in. (36.8 cm)
Purchase: Nelson Trust
58-61

75

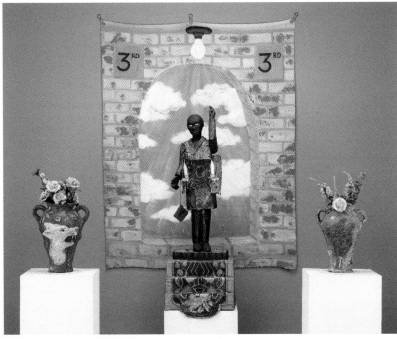

Plate 51
Subway Preacher, 1984
wood, canvas and mixed media
86 x 56 x 31 in. (226.1 x 142.2 x 78.7 cm)
Acquired through the generosity of
Michael Weaver, M.D.,
Paul and Bunni Copaken,
Larry and Stephanie Jacobson,
and the Nelson Gallery Foundation
F93-23 a-l

Alison Saar
American, b. 1956

Alison Saar uses visual storytelling to comment on the anxieties and social incongruities of modern life. Created during her residency at The Studio Museum in Harlem, *Subway Preacher* addresses the relationship between outward appearance and inner spirit.

The work was inspired by a homeless man Saar encountered often in the subway. He preached not through the spoken word but through the sanctity of his presence. Outwardly poor yet spiritually rich, his heart is enshrined in his chest like a holy relic. The nails in the preacher's head and the reflective glass within his chest cavity make reference to the *nkisi nkonde* (spirit power figures) of Republic of Congo. His stance pays homage to early-20th-century African-American preachers like Father Divine and Daddy Grace. Saar's use of materials such as tin ceiling sheeting and chipped linoleum in her work underscores her intent to find the precious in society's cast-offs. *JS*

George Segal
American, b. 1924

Rush Hour is an iconic sculpture in Segal's body of work. This forcefully orchestrated composition of lonely figures wrapped in coats, walking in the same direction with drooping shoulders and lowered heads, reminds us of the deep isolation that we can feel even while surrounded by others. Arrested in mid-step and held for our observation, the figures are caught in a split second of their daily routine, going from home to job and back. The group also suggests a poignant image of our communal lives, in which anonymous individuals exist as collective forces oblivious to and unaware of their own destinies.

For *Rush Hour*, Segal selected friends and neighbors to be his real-life models. The bronze sculptures were made from a plaster cast formed from applying plaster-dipped gauze directly on the faces and clothed bodies of the models. Once it was cast in bronze, Segal brushed a patina on the metal sculpture by hand to impart a rich, painterly quality. *Rush Hour* invariably invites comparison to Auguste Rodin's *Burghers of Calais* (1885–1886), a group of six life-size bronze figures with lively, hand-worked surfaces. Segal has himself acknowledged that *Rush Hour* is his "complicated reaction" to Rodin's masterwork. *LF*

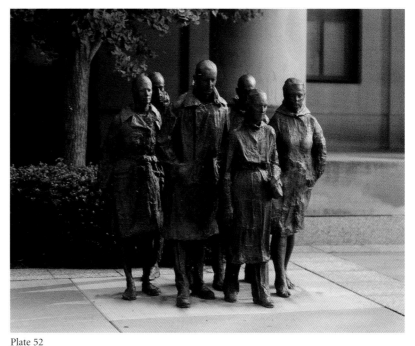

Plate 52
Rush Hour, 1983; cast 1995
bronze
64 1/2 x 20 x 19 in. (163.8 x 50.8 x 48.3 cm)
The Hall Family Foundation Collection at The Nelson-Atkins Museum of Art
25-1995/1-6

(left) George Segal applying patina to Rush Hour *at Johnson Atelier on April 26, 1995*

Judith Shea
American, b. 1948

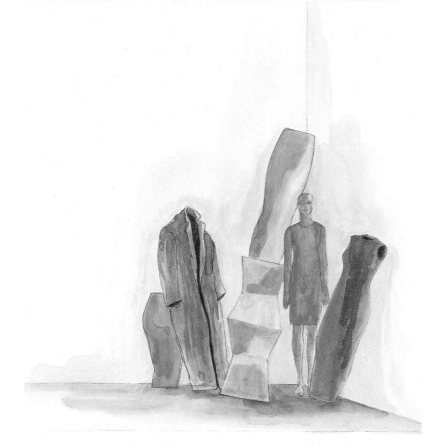

Judith Shea began her career in the 1970s as a fashion designer, but soon moved into making sculpture. Some of her earliest works were reliefs of clothing forms such as dresses, shirts and bodices made from plaster, paste, or wax. These works recall a trend in the late 1970s through the 1980s in which the human figure became popular in avant-garde art once again after long disfavor.

Storage is part of a series that Shea began in the early 1990s that featured sculptures leaning against a wall, as if forgotten or stored. Among the leaning forms in *Storage* are a man's empty coat; a woman's torso; and a version of Shea's *Endless Model*, which features an accordion-like base inspired by Constantin Brancusi's 1938 sculpture *Endless Column*. In contrast to the leaning forms, a reprise of Shea's 1992 work *Artist* stands upright, gazing outward.

As Shea's stand-in, the "artist" character raises a number of questions. Are artists neglected in a storeroom corner like the other characters? Or, as the only complete and upright figure, does she represent the potential of art to overcome time, place and gender? Finally, since this archetypal artist is female, does she challenge the traditional predominance of males in the art world? *JM*